One Nation

PATRIOTS AND PIRATES PORTRAYED BY N. C. WYETH AND JAMES WYETH

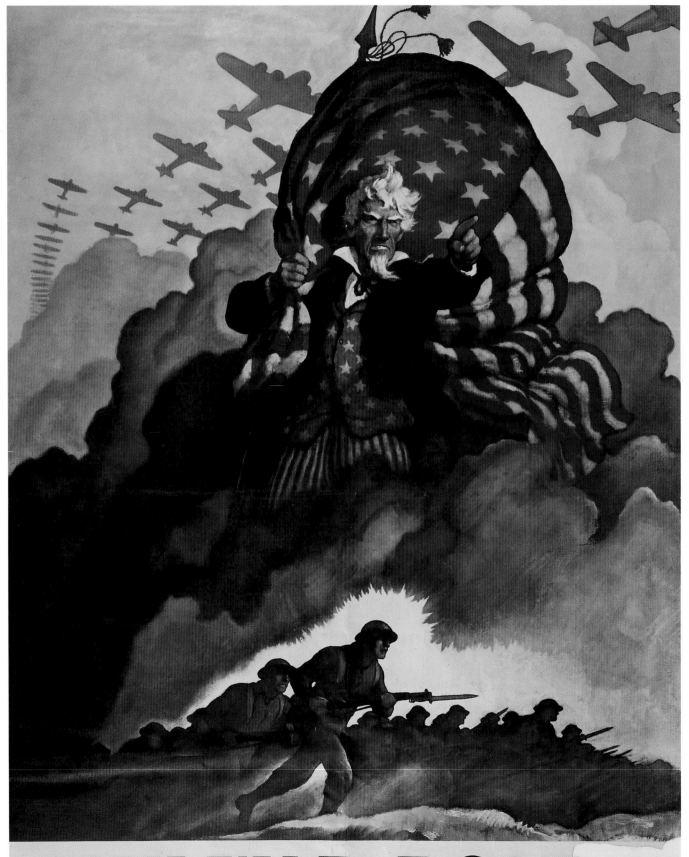

BUY WAR BONDS

U. S. GOVERNMENT PRINTING OFFICE : 1942-O-469204 WFPS 539

One Nation

PATRIOTS AND PIRATES PORTRAYED BY

N. C. WYETH AND JAMES WYETH

Introduction by Lauren Raye Smith

Essays by Tom Brokaw and David Michaelis

Bulfinch Press / Little, Brown and Company
Boston · New York · London

published in association with the
Farnsworth Art Museum

Exhibition Itinerary

Farnsworth Art Museum
Rockland, Maine
August 12, 2000–January 1, 2001

Brandywine River Museum
Chadds Ford, Pennsylvania
June 2–September 3, 2001

Russell Rotunda, Capitol Building
Washington, D.C.
January 14–January 21, 2001

Ringling Museum of Art
Sarasota, Florida
October 11, 2001–January 6, 2002

New Britain Museum of American Art
New Britain, Connecticut
February 15–April 30, 2001

One Nation is sponsored by MBNA America.

First edition

ISBN 0-8212-2700-9 (hardcover) ∎ ISBN 0-8212-2707-6 (museum edition paperback)
Library of Congress Control Number: 00-103209

Bulfinch Press is an imprint and trademark of Little, Brown and Company (Inc.)

Designed by MBNA America
Printed and bound by Amilcare Pizzi, Milan, Italy

Endpaper:
N. C. WYETH
Poems of American Patriotism, Endpaper Illustration, 1922

Frontispiece:
N. C. WYETH
Buy War Bonds, 1942

Contents

Introduction

Lauren Raye Smith

The history of America in the twentieth century, full of innocence and deceit, promise and disappointment, has been witnessed and chronicled by two members of the most famous family of artists in America, the Wyeths. N. C. Wyeth (1882–1945) was the most prominent illustrator of his day. In addition to illustrating classic novels and magazine articles, N. C. was called on by the U.S. government and military agencies to create images that would stir the hearts of his fellow Americans with a powerful emotion, patriotism. As the century aged and matured, however, so did the American public. Events conspired to strip the public of their innocence, and words like "Vietnam" and "Watergate" became heavily laden with new meaning. What it meant to be "patriotic" was no longer clear. James Wyeth (b. 1946), the grandson of N. C. Wyeth, came of age in the 1960s, perhaps one of the most tumultuous decades of this century. He has witnessed and, more important, recorded artistically many of the events and people that have shaped this new, more informed American public. This exhibition and catalog bring together a collection of the "political" works of these two artists in an exploration of our nation, a nation founded by both "patriots" and "pirates."

N. C. Wyeth, the founding father of a great artistic legacy, established his reputation as the premier illustrator of the country during the golden age of illustration. From the beginning of his career, he was determined to paint American subjects in a fresh and wholly American way, not to be swayed or influenced by past European masters. He was passionately interested in the events and people that established our country, and delighted in depicting events such as Washington at Yorktown and Lincoln giving his second inaugural speech. He was a master at projecting himself into the scenes he was painting, giving them a veracity that few others could accomplish. He became sought after for his quintessentially American illustrations. There is a romanticism and idealism to most of his works: the heroes are strong and virile, the flags wave majestically, victory is always at hand. His images echo the great speeches of Wilson, Churchill, and Roosevelt, and are the pictorial equivalents of "We have nothing to fear but fear itself."

Contrasting with the confident message of N. C. Wyeth is the sense of doubt visible in the eyes of President Kennedy as depicted by James Wyeth. He did not deify the slain president, on the contrary made him seem almost too human. As the media has expanded its coverage and power in the later part of the twentieth century, the American public has been given more information about its leaders, particularly their foibles, inconsistencies, and idiosyncrasies. The press exposed the Bay of Pigs operation months before the D-Day, resulting in the fact that the public was more informed about it than many of the participants. The Vietnam War became our first opportunity to witness the carnage of war each night on the evening news. We were also able to watch the fall of a president in the 1970s, and witness

and record the lies he told along the way. This is the Washington that James has been a part of, and he has explored and exposed its complexities over the years with a toughness and reality that comes from knowledge.

Consider the two artists' depictions of Thomas Jefferson. N. C.'s Jefferson is a solemn thinker, working late into the night on a speech, putting great thoughts to paper in the glow of candlelight. James takes a less scholarly view of the man, and there is haughtiness in the Thomas Jefferson from James's brush. In the two portraits he has strong features, piercing blue eyes, and a determined expression. *Dome Room* also shows Jefferson as confident, a small smile on his lips as he gazes out the window. His mistress Sally Hemings lingers in the doorway, a small uncertain figure, just leaving or arriving, but afraid to disturb the master either way. This is not the pensive, cerebral Jefferson of N. C., but Jefferson the man, the id evident.

Identical media can have drastically different results in the hands of these artists as well. Abraham Lincoln basks in the glow of the flag as he prepares to give his second inaugural speech in the small pencil study by N. C. He appears as a king, crowned in the glory of the nation, large billowy clouds surrounding him as he turns his face to the sky. James uses his pencil line to a far different effect. With it he describes the worry lines in the forehead of Colson as he testifies, the severity and intensity in the face of Haldeman, and the disbelief in the eyes of Judge Sirica as further evidence is revealed implicating the hallowed office of the presidency.

The White House appears in the work of N. C. and James in very different incarnations. *Building the First White House* by N. C. shows George Washington in consultation with James Hoban, discussing the progress of the building that will become the home and office of the leader of the nation. Well-dressed bystanders gaze in awe while workers study plans intently or haul building materials to the site. The building itself, bearing a resemblance to the Parthenon, is glowing in the spotlight of the sun, evoking the promise of the new democracy. The White House in the work of James Wyeth is a quieter place. The grandeur of leading the nation diminished, the White House, though still majestic, is not on the scale of N. C.'s portrayal. In *Christmas Eve at the White House* a single light glows in the cool purple night, an indication that someone is awake. This small light and the wreath that goes nearly unnoticed hanging from the balcony lend an air of warmth to the home.

The spirit of manifest destiny has continued into this century and man has reached further and further in search of new territory. In 1926, Commander Richard E. Byrd flew over the North Pole for the first time. To commemorate this flight, N. C. was commissioned to paint a mural for the National Geographic Society. In typical N. C. style, he was not content to paint the scene as everyone associated with the expedition described it, as an unremarkable day. He had to elevate the picture, to make the drama of the image befitting the historical significance of the flight. The plane cuts a dark arrow through the gloriously colorful sky; aqua blue water snakes its way around white polar caps. (*Through Pathless Skies* is not included in the catalog.) This exploration into uncharted territory can be compared to the space race of the late 1960s and early 1970s. A group of artists, including James Wyeth, was invited to participate in a program called "Eyewitness to Space" sponsored by NASA and the National Gallery of Art in Washington, D.C. Given free rein of the NASA facilities during the momentous Apollo blast-off and other events, James commonly chose scenes that leaned toward the ironic rather than the breathtaking, a rocket booster on its side being towed to the launch pad; a launch pad paired with an old red bicycle. He was not completely above awe,

however, as is evidenced by the starburst blast-off of *T-Minus 3 Hours 30 Minutes and Counting,* an image N. C. would have savored for its drama and intensity.

An artist has a great power, the ability to create images that will influence society's future perception of events. In this group of works by N. C. and James Wyeth we have the unique ability to trace a century of changes and challenges in our nation through a single family, and to speculate on how their respective time periods may have influenced their work. With this exhibition we are not attempting to define the "patriots" or the "pirates," but to encourage that discussion, or perhaps debate, among the viewers. One nation: these two words compel most Americans to complete the phrase learned as schoolchildren, standing, hands over hearts, facing the American flag, "under God, indivisible, with liberty and justice for all." Whether it is said with feeling or simply by rote performance, it enters the subconscious, perhaps a child's first brush with "patriotism," this pledge of allegiance to our United States. If this loyalty, instilled in youth, was tested later in life, however, would most Americans be proved "patriots"? Or would they be exposed as "pirates"? And who would decide which was which?

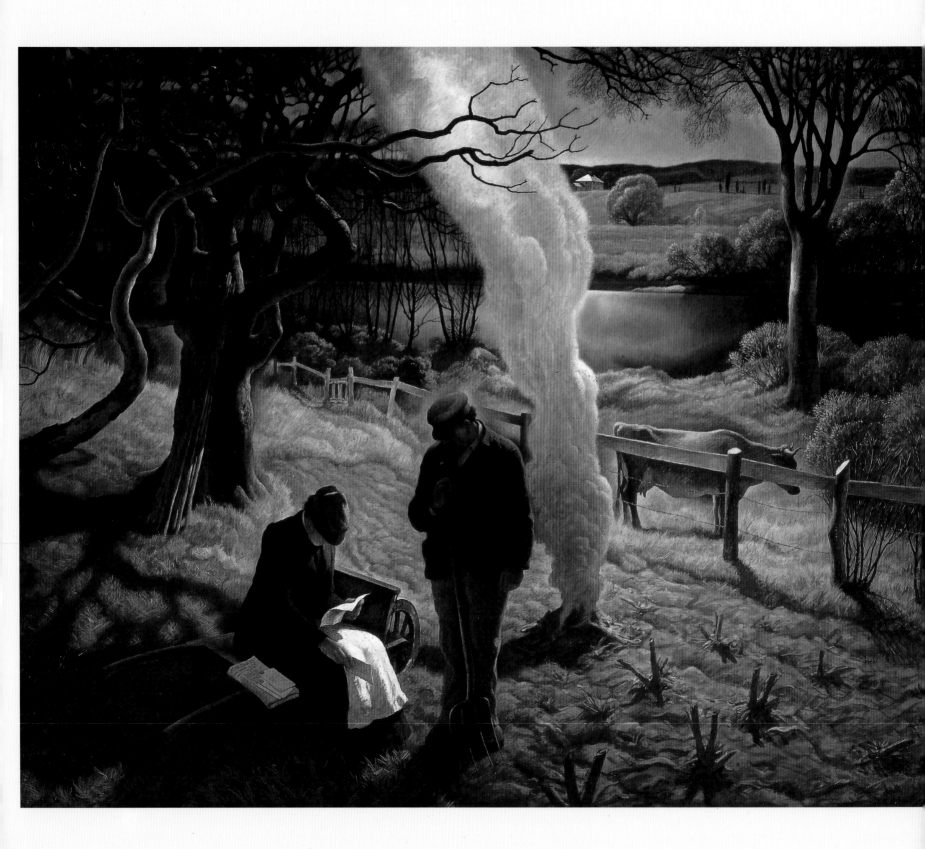

Words and Images

Tom Brokaw

*P*atriots and pirates, two old-fashioned words of roughly the same length sharing many of the same consonants and vowels, roll off the tongue in similar fashion, but when they land the immediate impressions are distinctly different. One says "honor and loyalty," the other, "thieves and terror." However, in usage and perception those distinctions are sometimes blurred.

The late Richard Nixon, forced to resign the presidency in disgrace, defended many of his most egregious and illegal acts in the name of patriotism. The cheerful, fun-loving troubadour Jimmy Buffett likes to call himself a pirate as he strolls across concert stages in tropical dress, singing hymns to cheeseburgers in paradise.

It's helpful to keep those mutations in mind as you browse through the twin themes as represented by the legendary illustrator N. C. Wyeth and his gifted grandson, Jamie Wyeth. They represent a wide generational and historical span of the sensibilities of patriots and pirates in our lives.

N. C. Wyeth was a man of the first half of the century, roughly from Theodore Roosevelt to Franklin Delano Roosevelt, when America seemed to be framed in red, white, and blue bunting and the background music was "Yankee Doodle Dandy" or Kate Smith singing "God Bless America."

His powerful and evocative illustrations of a righteous Uncle Sam or a brave American soldier standing up to a malevolent Hun, the stirring scene of a farmer growing crops to urgently feed an army, or a sailor, a soldier, and a factory worker all walking purposefully together were the images my parents and grandparents were raised on.

As a result, my earliest memories were of an unconditional patriotism in our lives. I vividly remember my grandmother often saying, "My country, right or wrong," or "Might makes right," when questions were raised about a controversial national policy. That is not to say they were blind, unquestioning followers of presidential, congressional, or other governmental directives and action. Their painful experiences during the Great Depression alone were enduring lessons in the fallibility of officials and institutions of great reputation and wrongheaded ways.

N. C. WYETH

◄ *The War Letter,* 1941

They could disagree and work to correct the wrongs without ever giving up on the idea of patriotism and loyalty to the nation and its ideals. Indeed, that was even evident during World War II when Americans responded as one to the menacing spread of fascism from the heart of Europe to the far reaches of Asia. Andy Rooney, America's favorite iconoclast, served in that war as a uniformed reporter for the military newspaper *The Stars and Stripes*.

When I interviewed him for my book about the remarkable people of that time, he first dismissed the claim they were the greatest generation. Moreover, Andy believes one of the reasons the U.S. forces did so well despite their late start is that there was always a healthy streak of skepticism mixed in with the great strains of patriotism. As a result, he believes, the U.S. forces were more resourceful and imaginative than their Teutonic, goose-stepping enemy who were blindly patriotic to a mad cause and often suicidal orders.

That alloy of independent thinking and national allegiance began to come unhinged during the time of Jamie Wyeth, N. C.'s baby boomer grandson. When Jamie was coming of age, there was a proliferation of images in new forms: television and cinema verité. Then, in rapid succession, a dashing American president was murdered, his successor drew America deep into a war in a far-off place, a war that even he privately doubted, another president was proved to be a crook, despite his protestations, and was forced to resign but not before he gave the world a new definition for plumbers, an otherwise honorable occupation.

Overnight, it seemed, many Americans, especially the young, lost faith in their country. The flag went from sacred symbol to fuel for ragged protesters.

It showed up on T-shirts and bandannas, boxer shorts and bikini bottoms.

Others, appalled by what they were seeing, hoisted the flag atop construction sites or displayed it prominently in their homes, cars, and businesses. They demanded constitutional amendments for the protection of the flag, dismayed when the courts ruled that burning a flag is a form of free speech and protected by the First Amendment.

With Vietnam over and Richard Nixon gone, the Soviet Union broken up, and the U.S. involved only episodically in regional conflicts, the debates about patriotism are muted now. There's more common ground and less hyperbole at both ends of the scale. Popular illustrations are more likely to invoke cyberspace than Stars and Stripes.

But the Wyeths have reminded us, in their memorable art spanning a century, of the resilience of the American way. We are a nation at once secure and in a constant state of renewal. A doughboy in World War I bears little resemblance to the draft age young man of the Vietnam era, yet they share a common citizenship and, most important, common privileges of that citizenship. We're reminded that the republic did not break apart or suspend its laws during the great constitutional crisis of Watergate. Indeed, in some ways, it became stronger as the rule of law took precedence in an imperial presidency. That, too, is a tribute to patriotism in the face of attempted piracy.

As I grow older I am more inclined to examine the shared passions and distinct visions within families. In the work of these two distinguished American artists we have a family album to treasure.

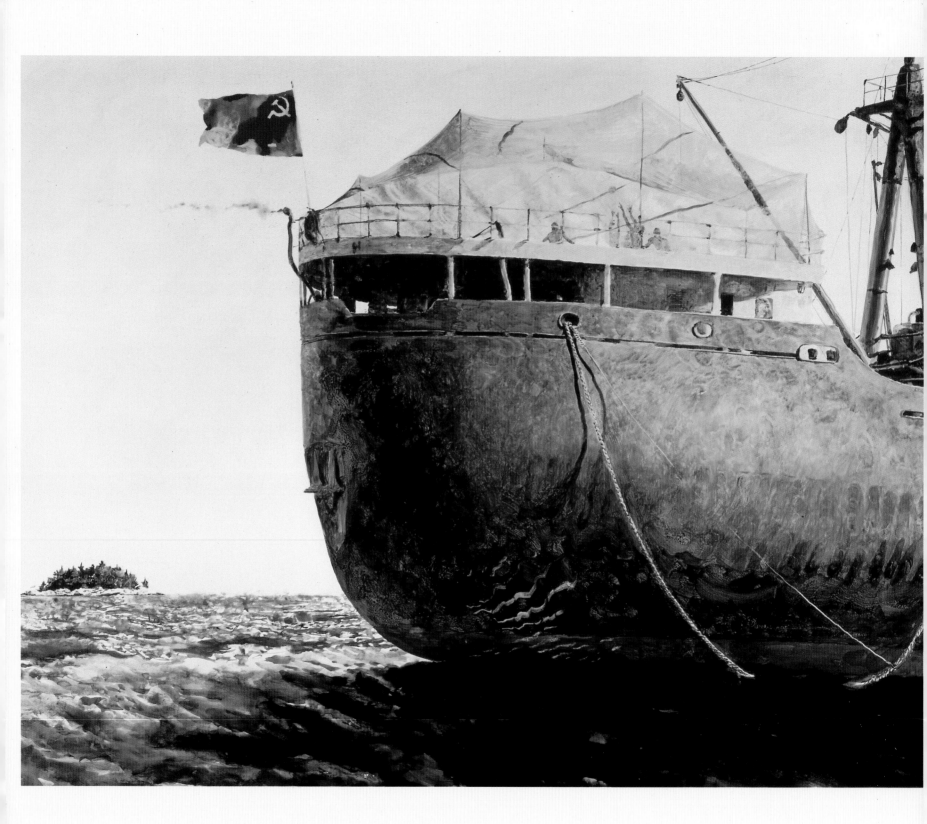

Solid American Subjects

David Michaelis

N. C. Wyeth raised his children to live like patriots and think like pirates. He taught them, in other words, to be self-reliant, free from outside influence, dependent on each other and the family's traditions. He schooled them in a kind of citizenship based on a deep emotional attachment to the land on which they had been born. Like the citizens of Athens, the Wyeths of Chadds Ford, Pennsylvania, lived autochthonous lives in the locality of their birth, resisting change from outside sources, imbuing their art with the hues and shades of the Brandywine Valley and, in some works, with the very earth itself.

"A man *must* live in the country he interprets," Wyeth insisted. "He can only interpret the country in which he was *born* and where his people lived before him."

N. C. Wyeth was born in Needham, Massachusetts, to parents who linked the Old World and the New. Wyeth grew up continually torn between American and Swiss forefathers. His paternal ancestors, landowning Wyeths stretching back to 1645, had destroyed tea at the Boston Tea Party, marched to the alarm at Lexington and at Concord on April 19, 1775, and fought the Redcoats on Bunker Hill. From the Wyeths of Cambridge, Massachusetts, and from his father, Andrew Newell Wyeth, a Boston hay inspector, he developed a lifelong habit of idealizing his country's past.

His maternal grandparents, meanwhile, were Swiss immigrants. His grandfather Jean Denys Zirngiebel came to America in 1856 and became a successful florist, with a national reputation for developing new strains of pansies. Flowers from the Zirngiebel greenhouses were shipped weekly to the White House and War Department during the second of President Grover Cleveland's administrations. From the Zirngiebels of Needham, N. C. Wyeth inherited a tradition of longing for distant homelands. His mother, Henriette Zirngiebel Wyeth, a lifelong sufferer of homesickness and depression, passed on to her oldest son a profound, almost crippling form of nostalgia, itself a Swiss phenomenon.

Dual identity appeared early in Wyeth's life and never left him. "Although I receive a steady flow of inspiration from the circulation of Swiss mountain blood in my veins," he once told his mother, "I also get tremendous help from my thoughts of this astonishing country of ours, and particularly from my home in Needham. It is right that dear old Switzerland is *your* background of romance and idealism; it is right that my essential background is faith in and love of my natal country." He proudly added: "The tremendous idealistic advances of the United States in the course of 140 years are astounding and cannot be matched by any other country on the globe."

The first decades of the twentieth century were a good time to be young and American. N. C. Wyeth was as emphatically patriotic as a first-generation immigrant: "I am an *American*," he wrote in 1914, on the eve of Europe's collapse into the Great War. "I do not weep

JAMES WYETH

◀ *Russians Off the Coast of Maine,* 1988

every time I see the Stars and Stripes—no I'm not that kind; but, my God, I was born here and nourished on this continent's soil."

Wyeth's patriotism was born, as he was, in the nineteenth century. He made adventure, nature, the "vastness of things" his earliest personal themes. America was his canvas. "I have no enthusiasm to see Europe except perhaps the homes of my people and a mere curiosity to see the country, but nothing deeper," he announced in 1903. "There are just as great subjects here to paint. I've fully decided what I will do. Not altogether Western life, but true, solid American subjects—nothing foreign about them."

In 1904, and again in 1906, he made sketching trips for popular magazines to what was still the Old West. In 1905, he rode, outfitted as a cowpuncher, in President Theodore Roosevelt's inaugural parade. He wore wide-brimmed Western hats the rest of his life, entering rooms with a bouncing stride. His language ("He was always saying 'That's bully!'" one of his children remembers) savored of the American Empire, but his letters made him sound like a Swiss soldier, with their continual expression of "*home-spirit*," their ceaseless longing for a lost homeland, a sense of oneness with nature, and life in an extended family.

N. C. Wyeth's contributions to *One Nation* are the Solid American Subjects he set out to paint as a young man and continued to explore until the penultimate day of his life, when he left on his easel a portrait of George Washington, *First Farmer of the Land*. Here are the muscular, masculine images of the American Empire: Marines come smashing ashore. A twentieth-century tank pushes through the old walled city in Jerusalem, its side gun mounts barely clearing ancient archways. John Paul Jones stands ready for battle, knees locked, shoulders squared, chest out. Stonewall Jackson, flanked by livid sundown clouds and his warhorse, stares down defeat. Women in American history often appear as passive recipients of the nation's honors. We know well the familiar image of mourning widows, mothers,

and daughters, receiving a folded flag at the graveside of the fallen soldier. As depicted by N. C. Wyeth, the ninety-year-old Barbara Frietchie, bravely brandishing the flag shot from her attic-window flagstaff by Lee's army in Frederick, Maryland, may be one of the few women ever shown in action with her country's flag. Here, in short, are men and women who live for the chance to die for their country—patriots.

In 1911, with the publication of the first book in the Scribner Illustrated Classic series, N. C. Wyeth became famous also for painting pirates. Throughout Wyeth's career as an illustrator, America was in a constant cycle of pirates and patriots. In times of prosperity, pirates on Wall Street bled the wealth of the nation. When the country fell into chaos, patriotism was reborn; men and women on Main Street once again gave their lives for a cause larger than themselves. The values of self-sacrifice were ceaselessly pitted against the vices of self-absorption.

Among N. C. Wyeth's values none was higher than sacrifice. First as a son and later as a father, he found a natural part of his character in subverting his artistic goals in order to meet the emotional demands of a large, complicated family. In 1917, when America at last entered the Great War in Europe, Wyeth was officially asked on four separate occasions to go overseas as a war artist. Four times he put the needs of his young, growing family before the needs of his country, each time suffering a "period of real torture of mind to decide between *duty* and *duty*."

Typically, N. C. was merciless with himself as he wrestled over the decision. He vacillated wildly about the effect the Great War would have on his painting. On the one hand, he imagined that the Western Front would so completely degrade him as a man that he would be incapable as an artist of painting "big stuff for some time after the excitement had subsided." On the other hand, how could he turn away from the "war to end all wars"? N. C. Wyeth had a gift for painting the human figure in combat. Yet his response to war was more typical of the man than of the artist: he stayed at home and put the family first.

In the nine generations of Wyeths who have contributed to American life since 1645, only the first four fulfilled the Jeffersonian dream of an amateur citizen militia. The last three generations have used paintbrushes instead of guns to respond to the country's needs in time of war. For both World War I and World War II, N. C. Wyeth painted war bonds posters; in 1942, one N. C. Wyeth poster sold $200,000 worth of bonds; another took in $1 million. That same year, Andrew Wyeth, 4-F on account of an inherited pelvic condition, contributed to the war effort by painting a poster depicting American welders wasting no time lest the Nazi *Wehrmacht* overwhelm Allied manufacturing: "Our Enemies Will Use The Minutes We Lose!"

Faced with war at age eighteen, Jamie Wyeth confronted a decision no less black-and-white than his grandfather's struggle of 1917–18. In the increasingly polarized world of 1965–66, Jamie Wyeth's generation either went to Vietnam or burned a draft card and went underground. Wyeth had friends in the war. He also had friends who were protesting American involvement in Southeast Asia. "I was back and forth on the thing," he recalls. Wyeth joined the Delaware Air National Guard, taking basic training in Texas and serving as an airman from 1966 to 1971. He was on his way to a combat zone as a war artist when the Tet Offensive of 1968 kept all noncombatants out of action.

It was the era when bumper stickers at home warned Love It Or Leave It—as if anyone who had soured on America's commitment to a guerrilla war in Southeast Asia should get the hell out of America itself. Jamie Wyeth's widely renowned portrait *Draft Age* (1965) is an icon of that factional era. Monhegan Island, where Wyeth found the subjects of many early works, was no less a microcosm for the struggles of that divided time. In World War II, every eligible man on Monhegan fought for his country. Monhegan Island was the one place in America that could claim one-hundred-percent participation. The Vietnam War was a different story. One man from Monhegan went for his army physical with peanut butter smeared in protest across his buttocks.

During the Vietnam era, the island was a popular destination for the counterculture. In summer, freaks and longhairs could be found skinny-dipping and smoking dope on the backside of the island. The reaction of the older generation can be seen in Jamie Wyeth's *Islanders,* who sit in the shadows of their porch, taking cover behind the flag. Old Glory guards their privacy, shielding the memory of loved ones, now dead or far absent, and papering over feelings long buried at the core of the house.

Jamie Wyeth's early career as a national observer is full of rising pinnacles. In hindsight his development looks orchestrated, so gracefully did the artist move from phenomenon to phenomenon, subject to subject, place to place—Clan Kennedy to Cape Kennedy—with increasing subtlety and penetration and a mastery that is still hard to believe possible in one so young. But in fact, it took nerve and a willingness to be singular and even strange to paint these subjects, many of which were big news at the moment when the artist brought his ultra-personal and deadline-resistant gaze to the national scene. Jamie Wyeth's subjects often mirror the temper of the times, even if his personal point of view remains distinct and apolitical. Whether it's a NASA rocket pulsing on the launch pad or President Kennedy, absorbed by some inner struggle or unresolved idea, allowing his presidential attention to wander for an instant, or the duplicitous Long John Silvers of Watergate on trial, we are encouraged to witness the country's heroes and villains without presumptions.

From Thomas Jefferson and the rise of the rebellion against England to the fall of Richard Nixon, Jamie Wyeth's chronicling eye tells the story of the nation's evolution from pirates to patriots to pirates and back again. Seen alongside N. C. Wyeth's retellings of our cyclical history, these images remind us that there are always two sides to our national identity. Patriots (from the Greek, *patriotes,* from *patrios,* "of one's fathers") live for the chance to die for the land they will pass on to their sons. Pirates, willing to live at any price, die under no flag but their own.

NEWELL CONVERS WYETH

N. C. Wyeth was affected deeply by the historical significance of the Brandywine River valley, where he made his home, site of the Battle of the Brandywine in the Revolutionary War. In September of 1777 the British troops, under Sir William Howe, faced the American troops, commanded by George Washington, in bloody battle. Lafayette was wounded in this battle while aiding the Revolutionaries, who were outmaneuvered in this case and forced to retreat. It was in these surroundings that N. C. was inspired to create images of famous Americans such as George Washington, Benjamin Franklin, Thomas Jefferson, Abraham Lincoln, John Paul Jones, and Paul Revere. N. C. spoke of the effect of this land on his psyche in the following passage of a letter to his brother, Ed:

I was attracted more and more by the beautiful effects of nature, which were made very dramatic having been the identical "fighting grounds" on which was fought the "Battle of Brandywine." I would sit for half an hour at a time in some beautiful poetic spot which bore the scars of an earthworks thrown up by the Americans or "Redcoats," thinking of the wonderful contrast between the bedraggled, ragged, bloodstained soldiers of Washington, and the clear, pure, cheerful babbling brook till at last my imagination made me almost believe that I could see a Continental soldier lying down beside the brook, drinking of the cool water, the perspiration dripping from his tense face, and around his head a soiled, redstained kerchief falling half over his eyes. I became so carried away that I got up in search of relics, which of course was useless, but nevertheless my enthusiasm spurred me on to hunt and hunt.[1]

N. C. created an air of authenticity surrounding his depictions of these people as if he had been in their presence. He was creating the image of these Americans that will last through the centuries, in effect shaping the persona that will be remembered.

The following works are from a variety of publications illustrated by N. C. Wyeth, including a set of images created for a calendar called *America in the Making,* several illustrations from two books by Mary Johnston about the Civil War entitled *The Long Roll* and *Cease Firing,* and the complete series of illustrations from a book of verse entitled *Poems of American Patriotism.*

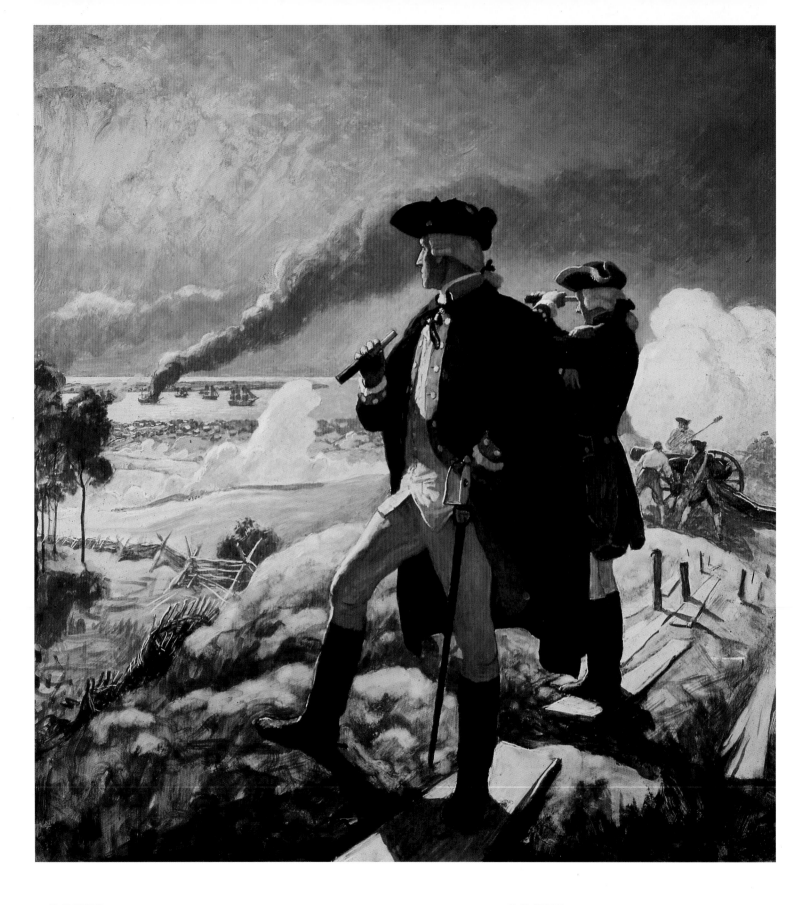

N. C. WYETH

1. *Washington at Yorktown,* 1940

N. C. WYETH

2. *Building the First White House Washington, D.C. 1798,* c. 1930 ▶

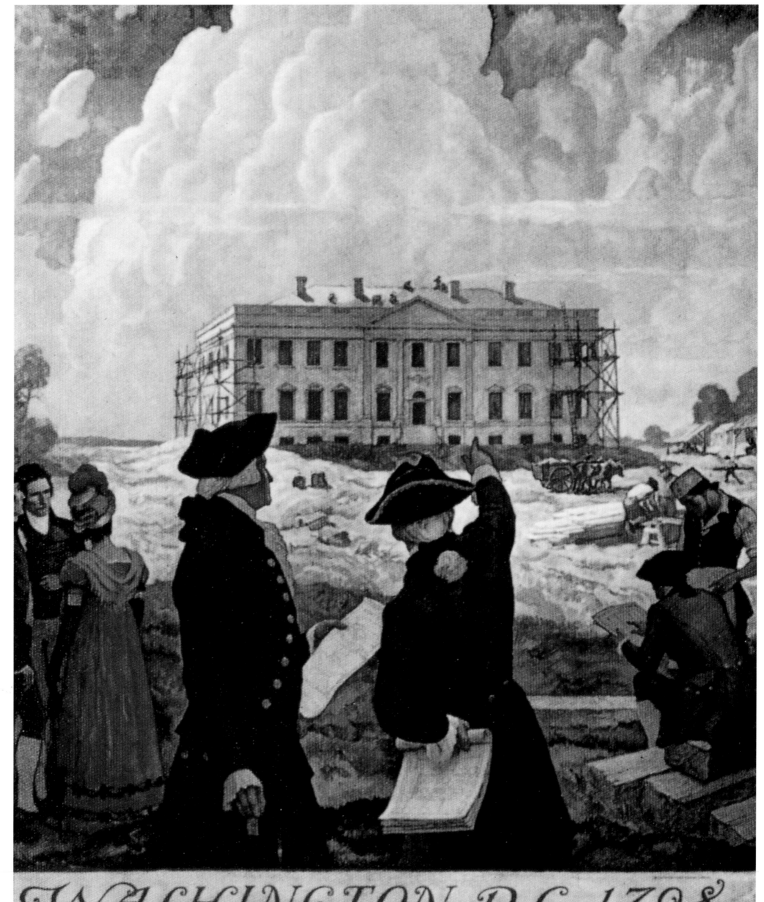

WASHINGTON D.C. 1798

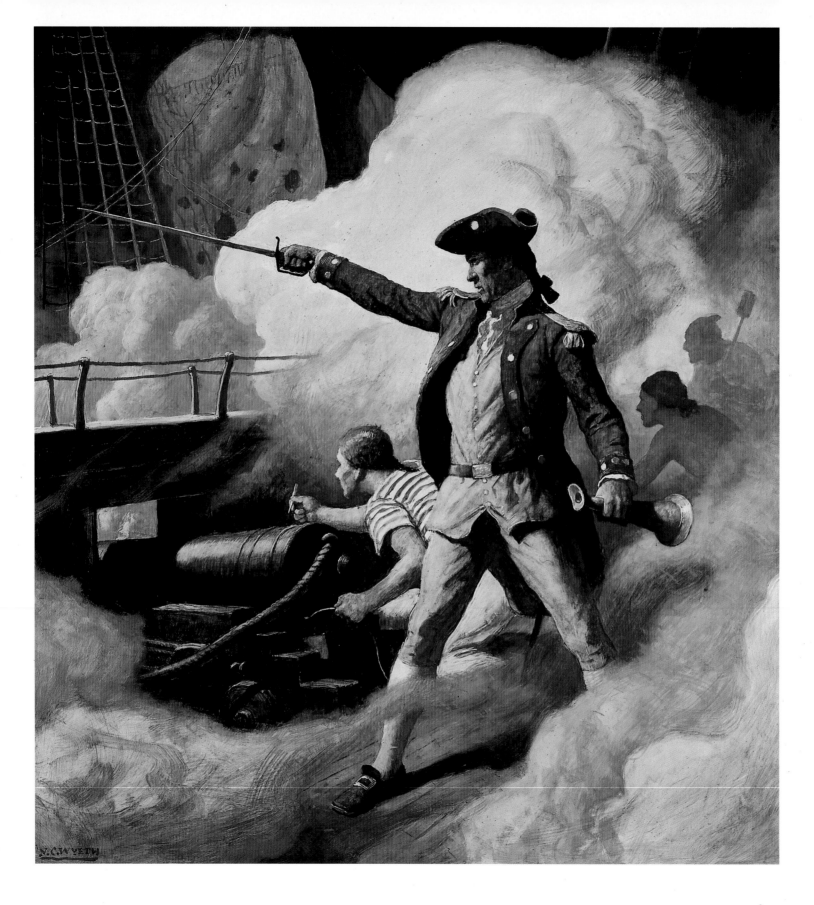

N. C. WYETH

3. *Captain John Paul Jones*, 1940

N. C. WYETH

4. *On the Sea Wall With John Paul Jones*, 1928 ▸

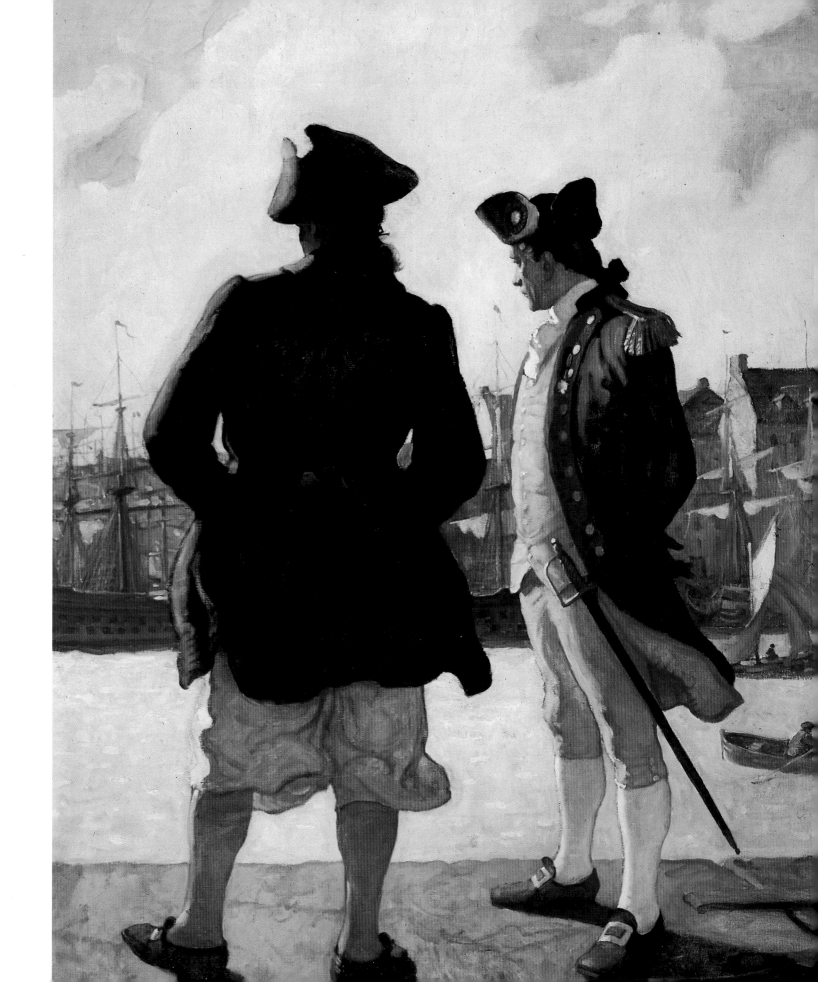

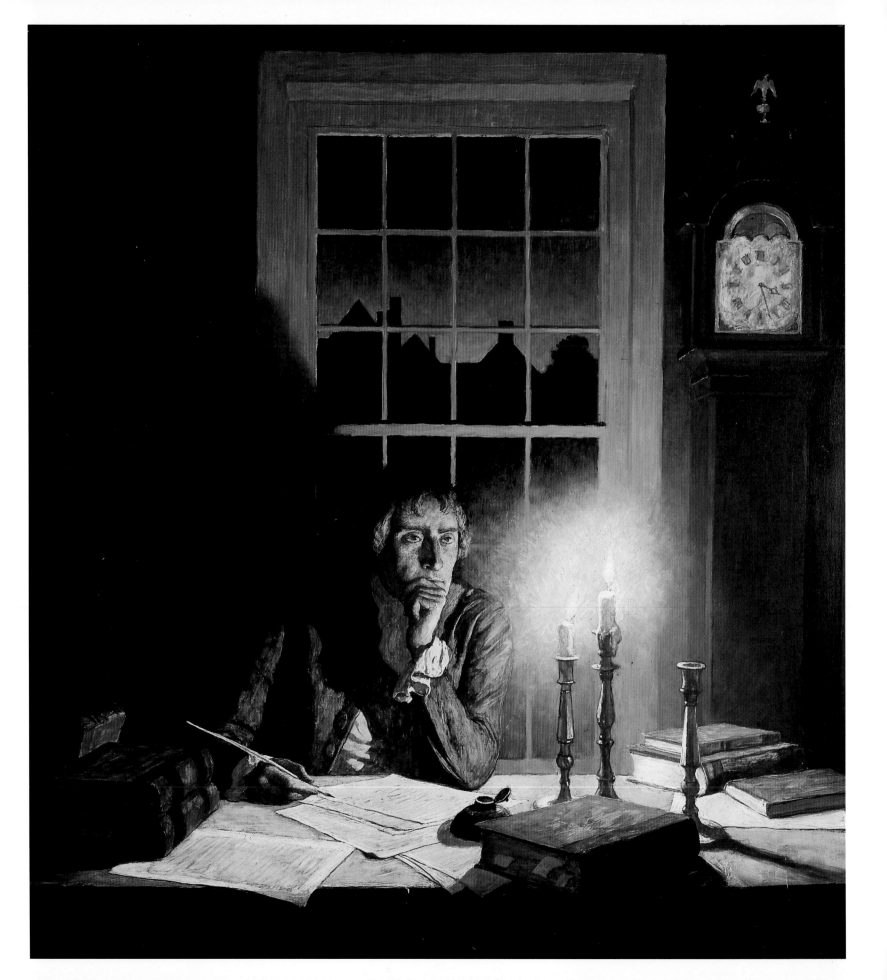

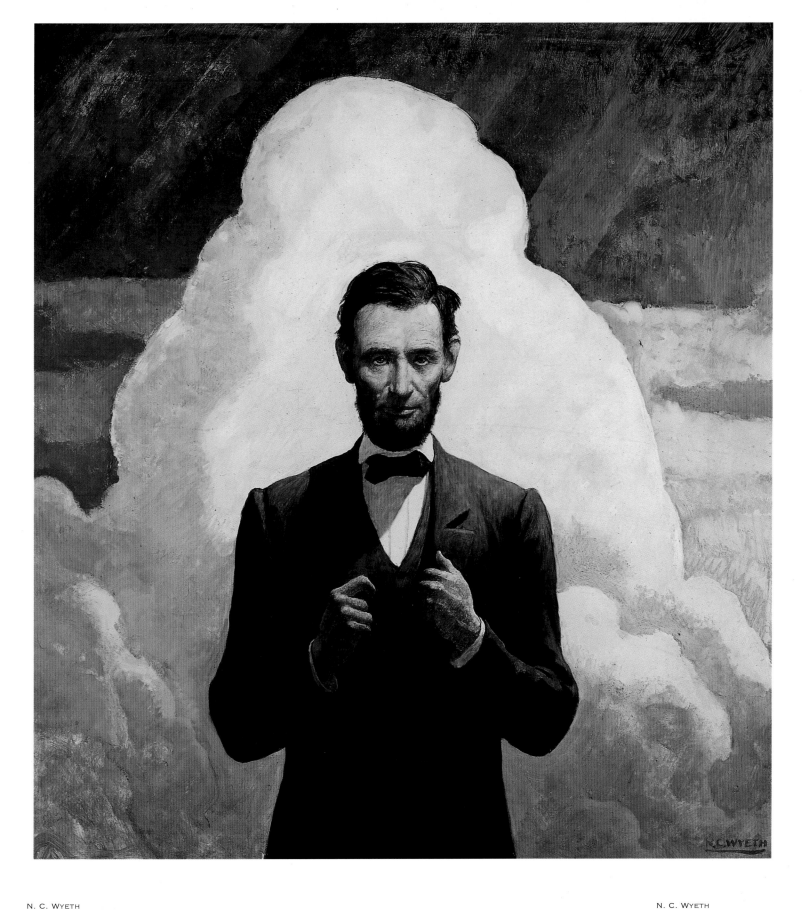

N. C. WYETH

5. *Thomas Jefferson*, 1940

N. C. WYETH

6. *Abraham Lincoln*, 1940

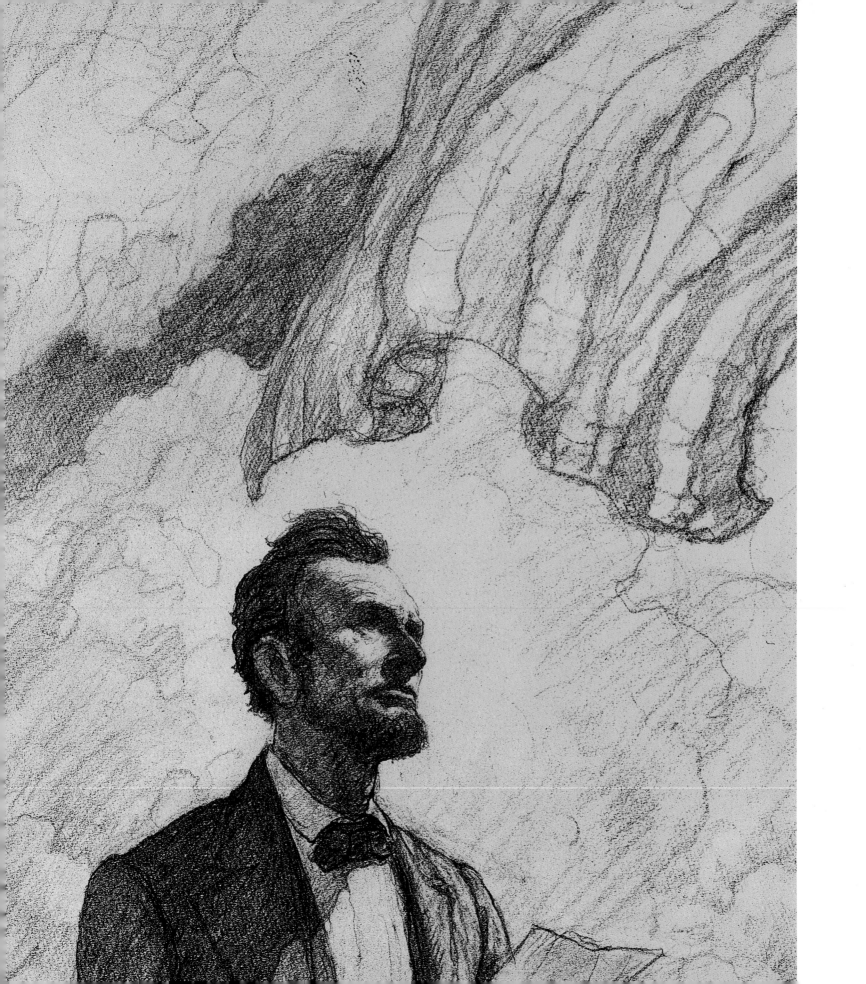

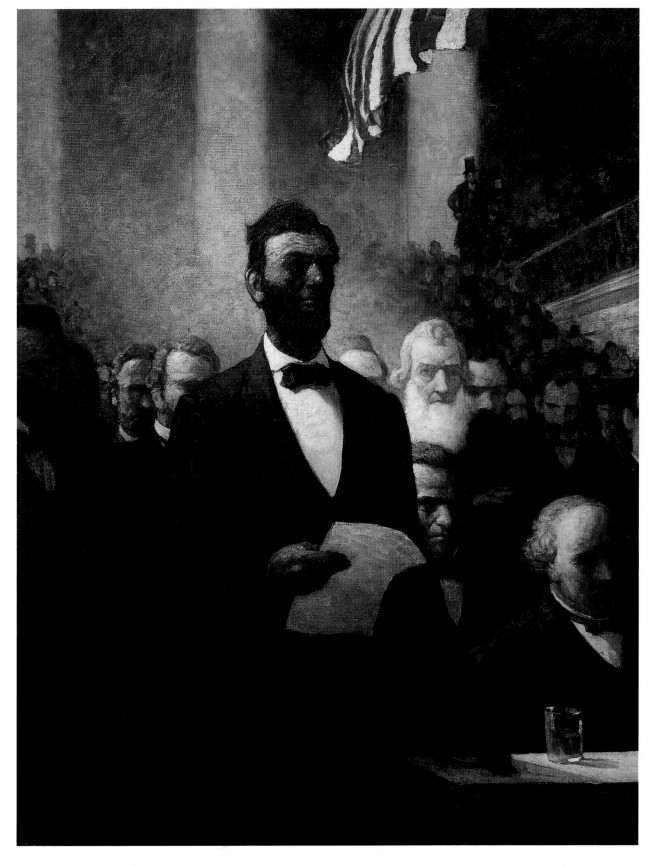

N. C. Wyeth

7. *Study for Lincoln's Second Inaugural Address*, c. 1923

N. C. Wyeth

8. *He Saved the Union. Lincoln delivers his second inaugural address as President of the United States, March 4, 1865*, c. 1923

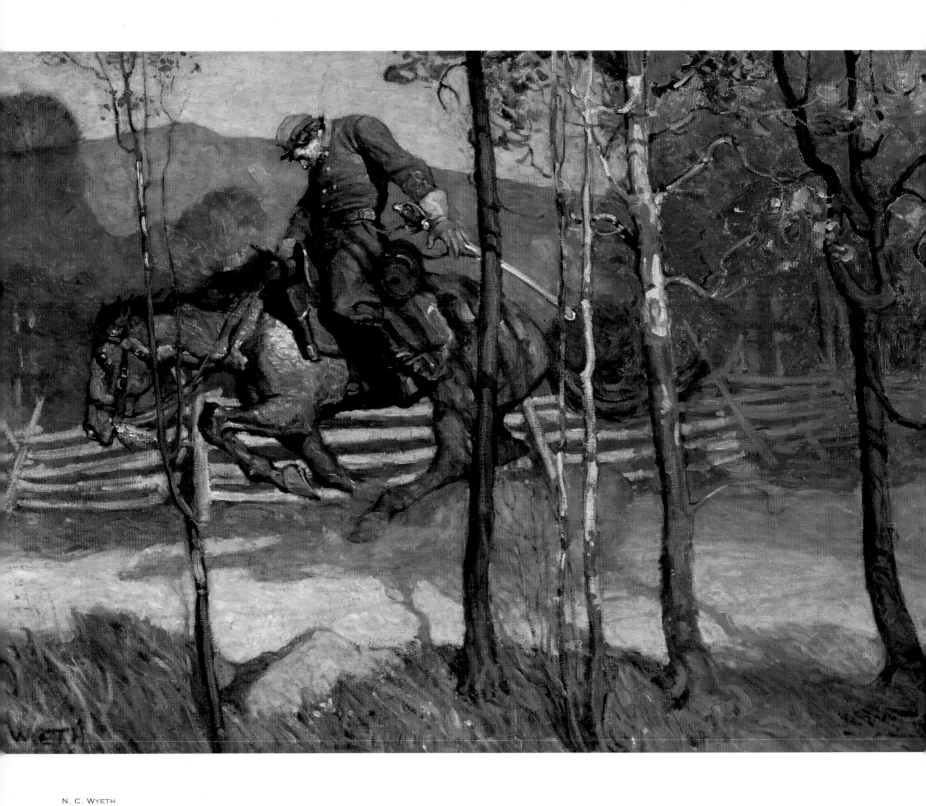

N. C. Wyeth

9. *The Courier*, 1912

N. C. Wyeth

10. *The Vedette*, 1910 ▶

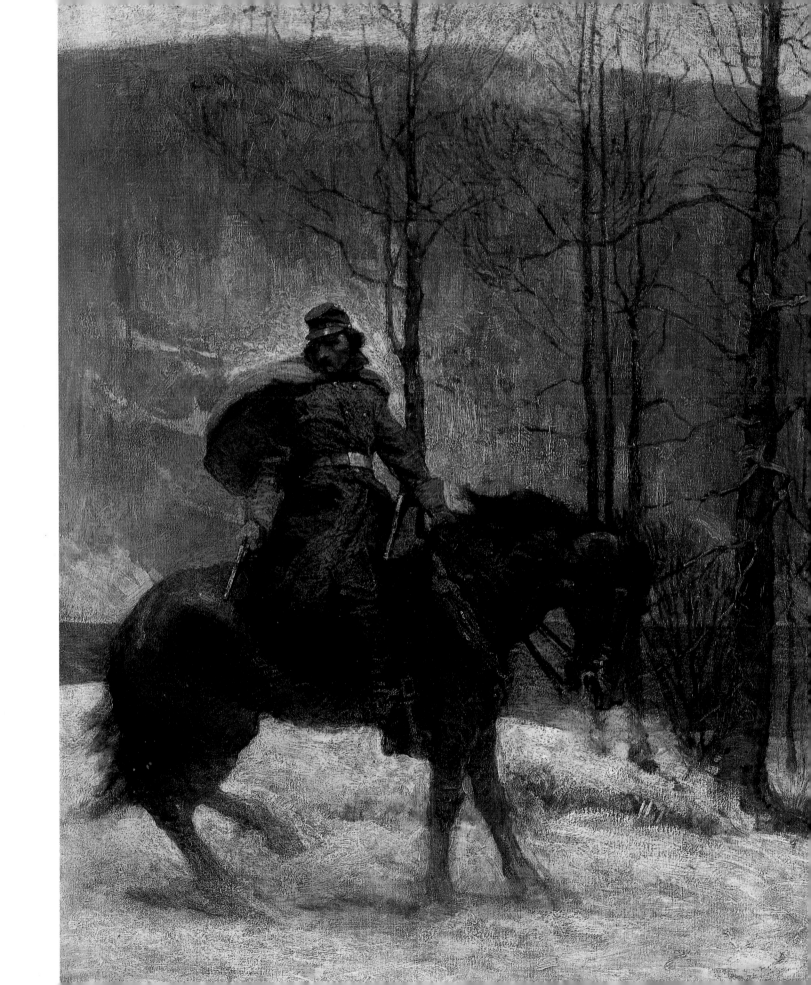

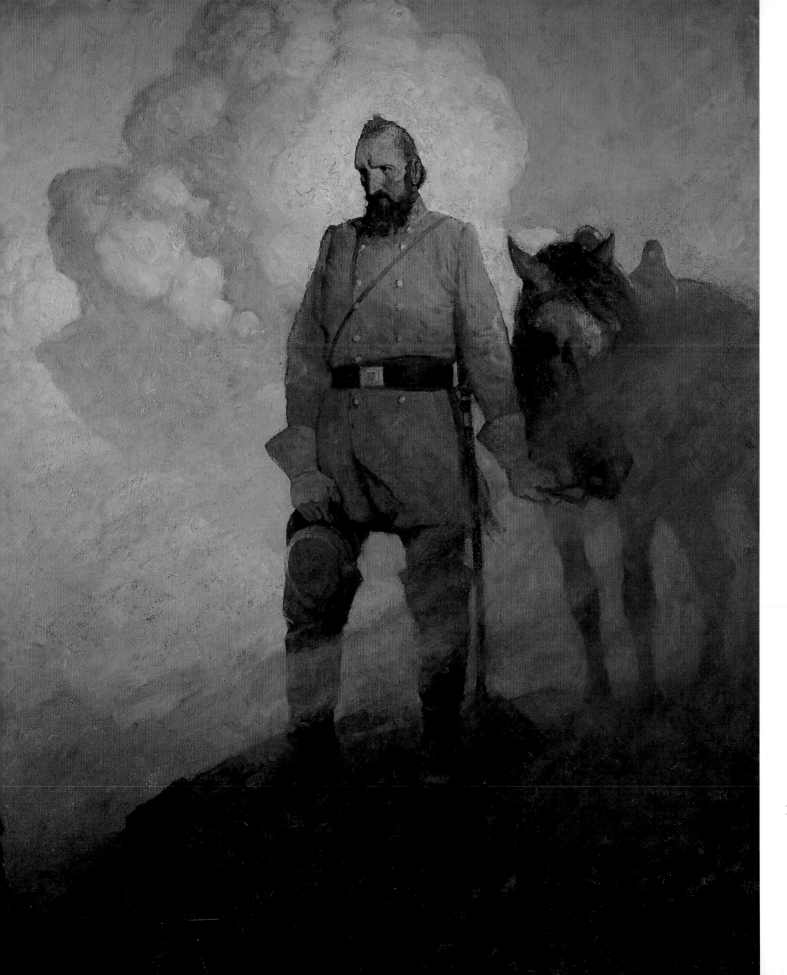

N. C. WYETH

11. *Stonewall Jackson,* 1910

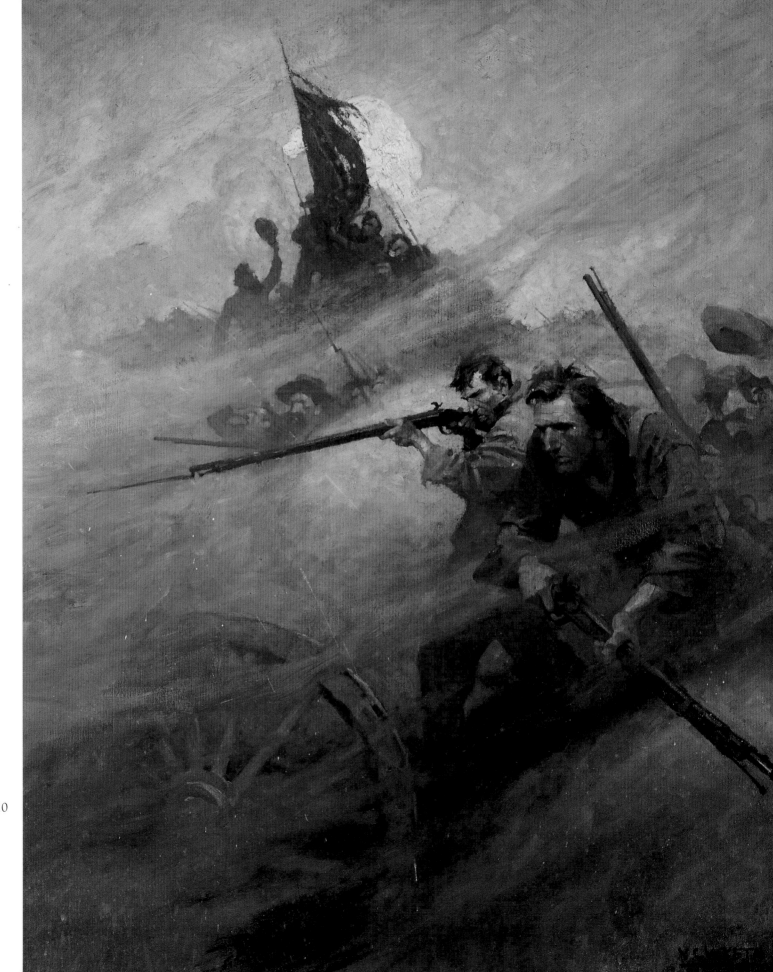

N. C. Wyeth

12. *The Battle*, 1910

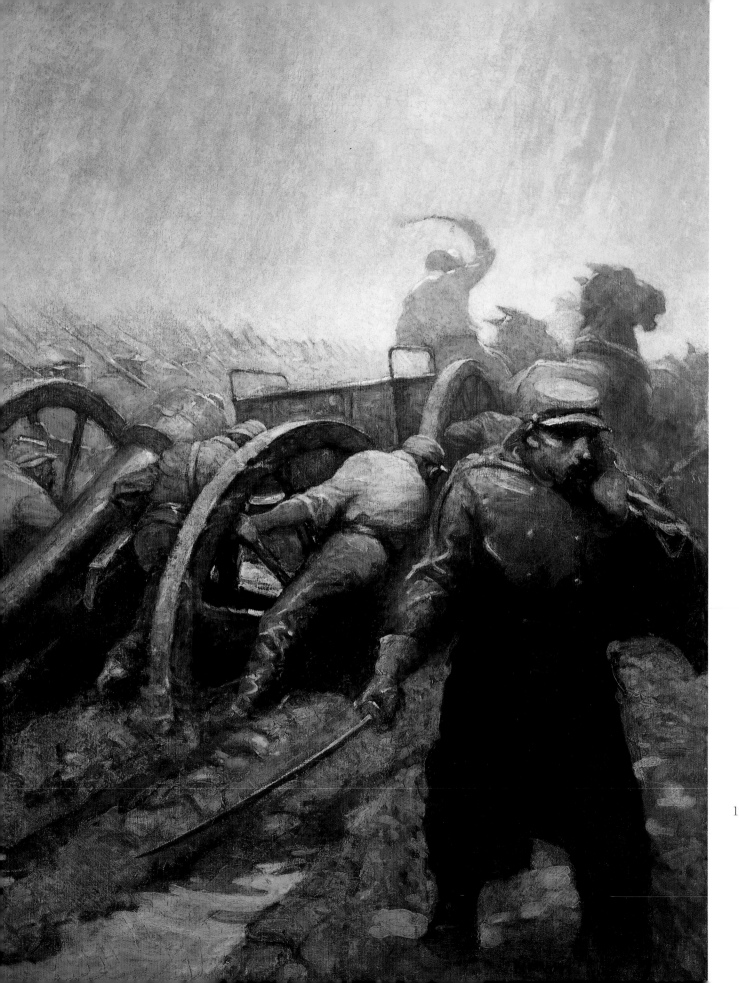

N. C. WYETH

13. *The Road to Vidalia*, 1912

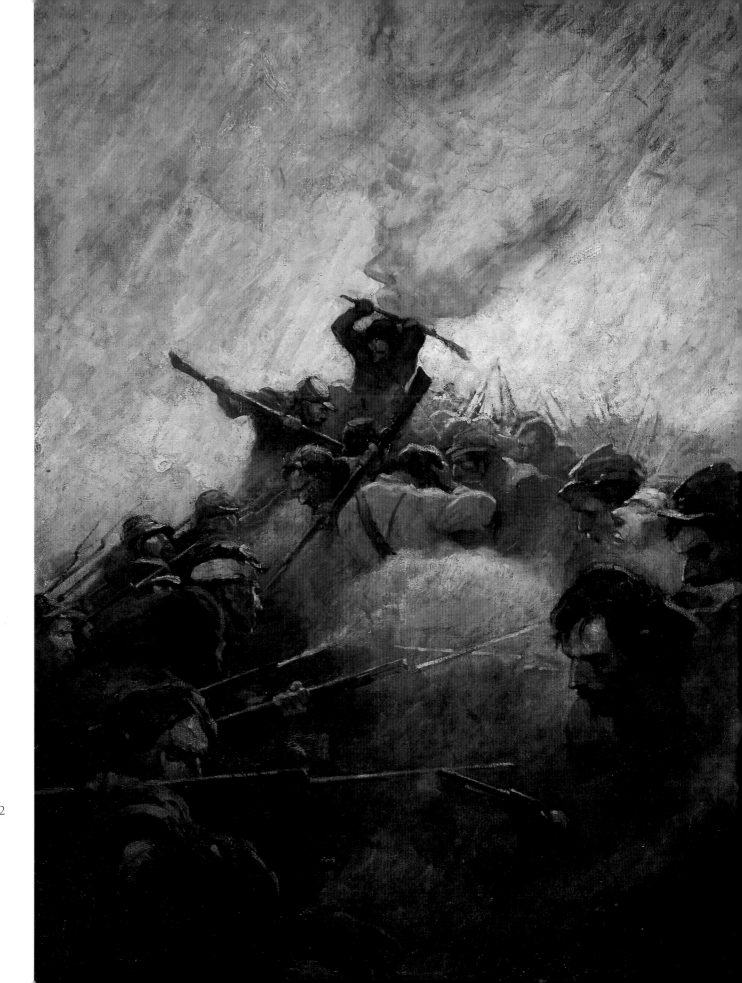

N. C. WYETH

14. *The Bloody Angle*, 1912

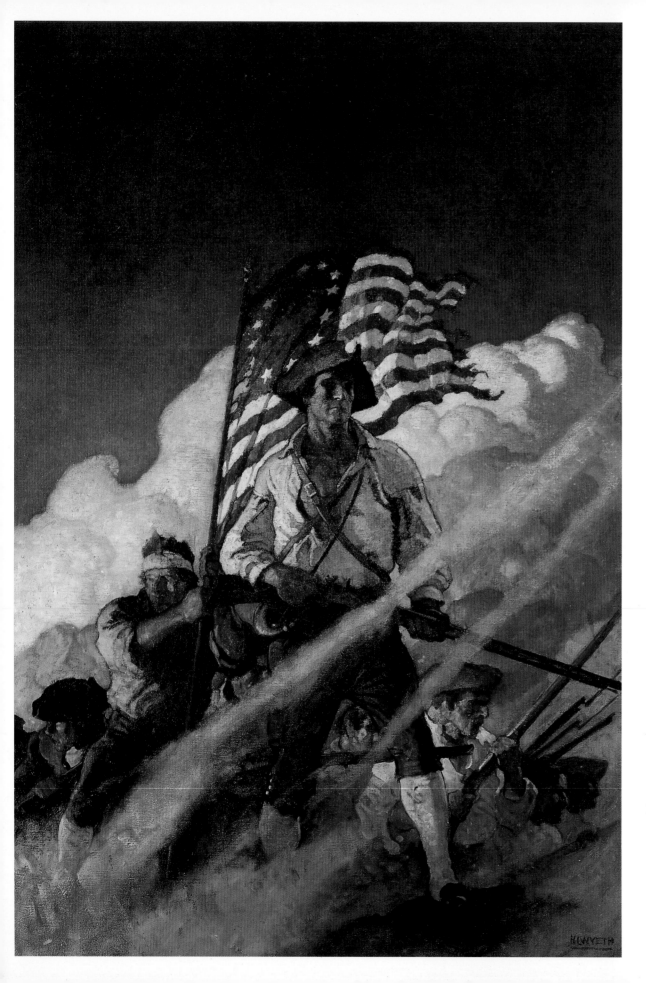

N. C. WYETH

15. *The Old Continentals*, 1922

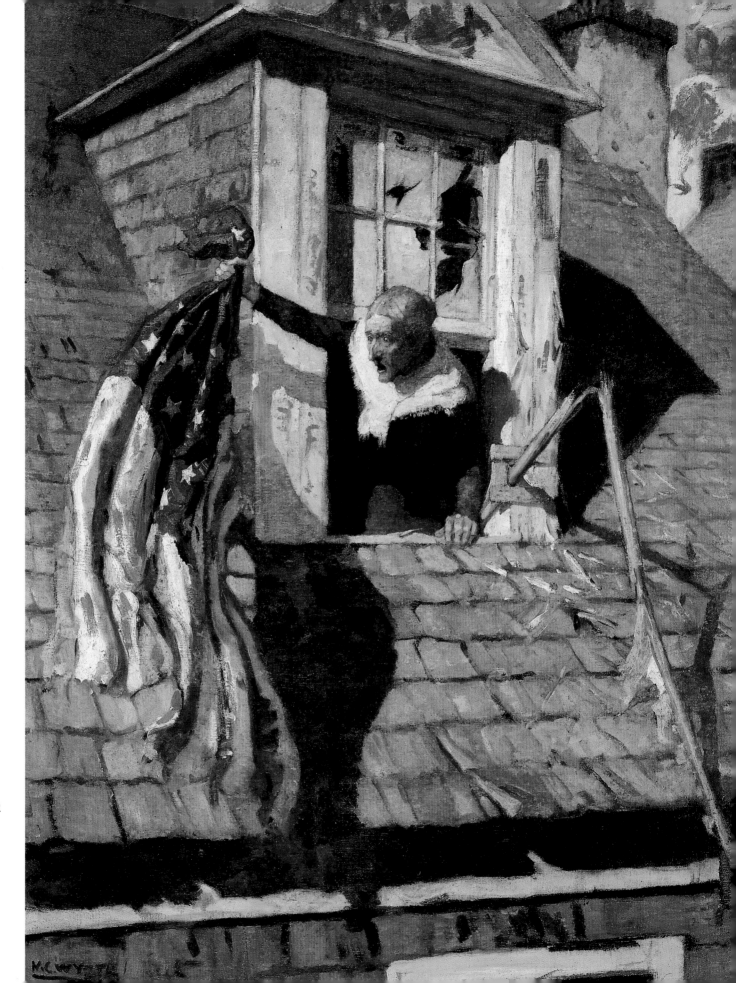

N. C. WYETH

16. *Barbara Frietchie,* 1922

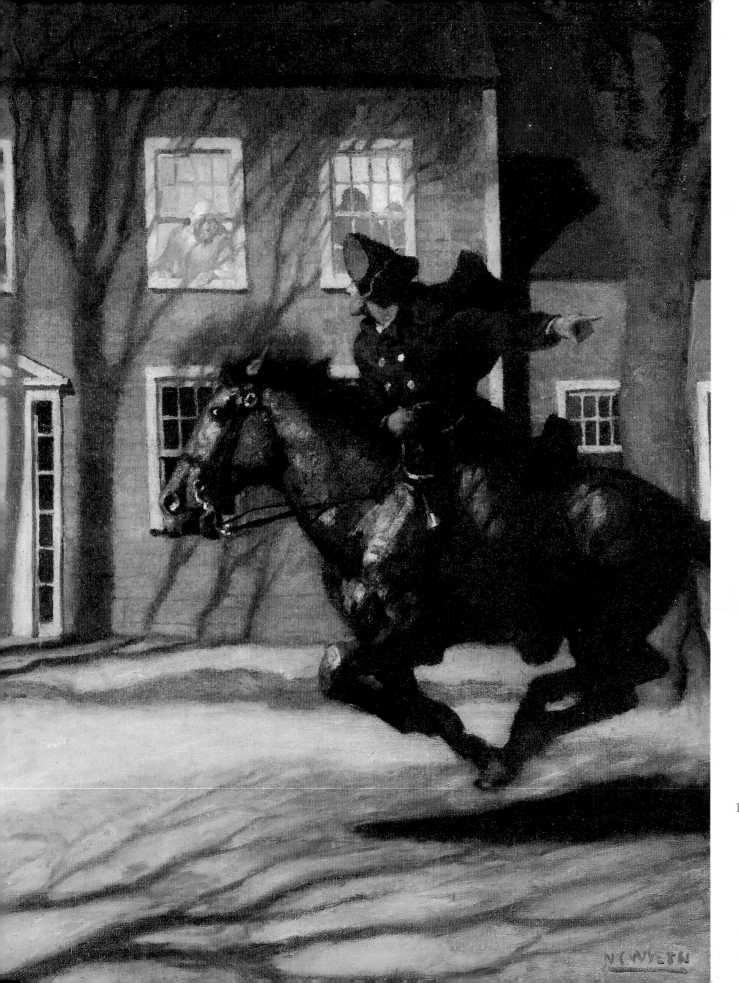

N. C. WYETH

17. *Paul Revere's Ride*, 1922

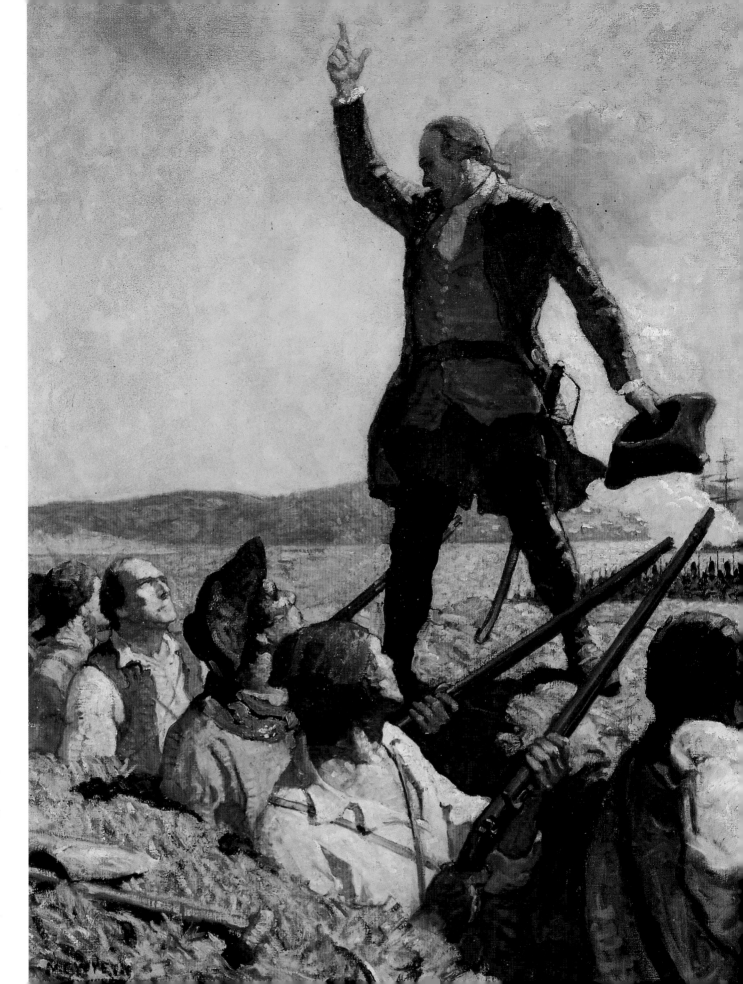

N. C. WYETH

18. *Warren's Address to His Troops at Bunker Hill,* 1922

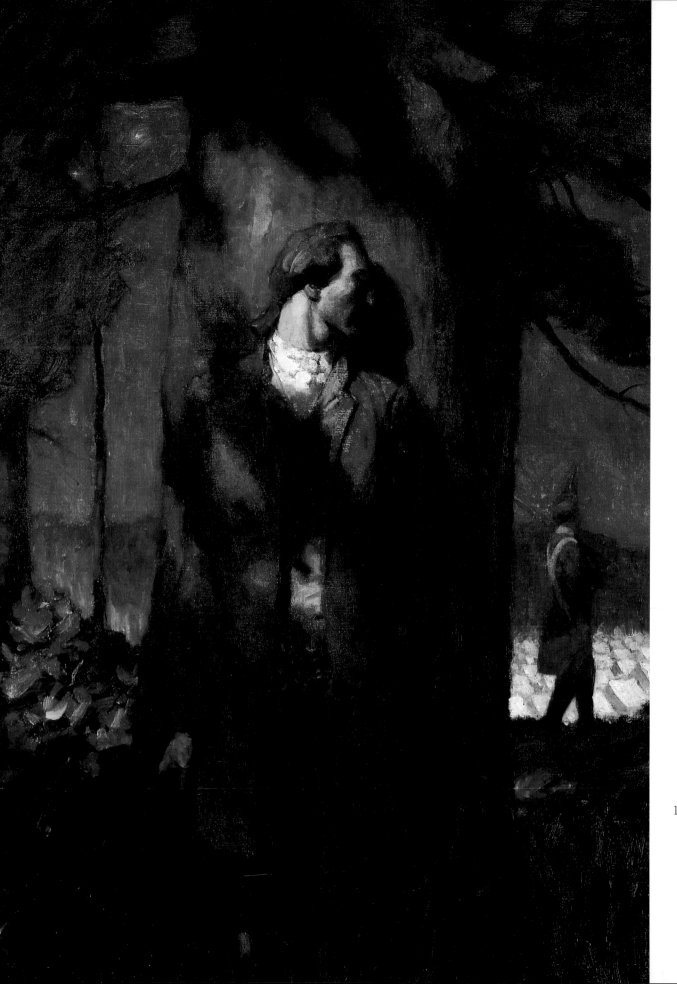

19. *Nathan Hale*, 1922

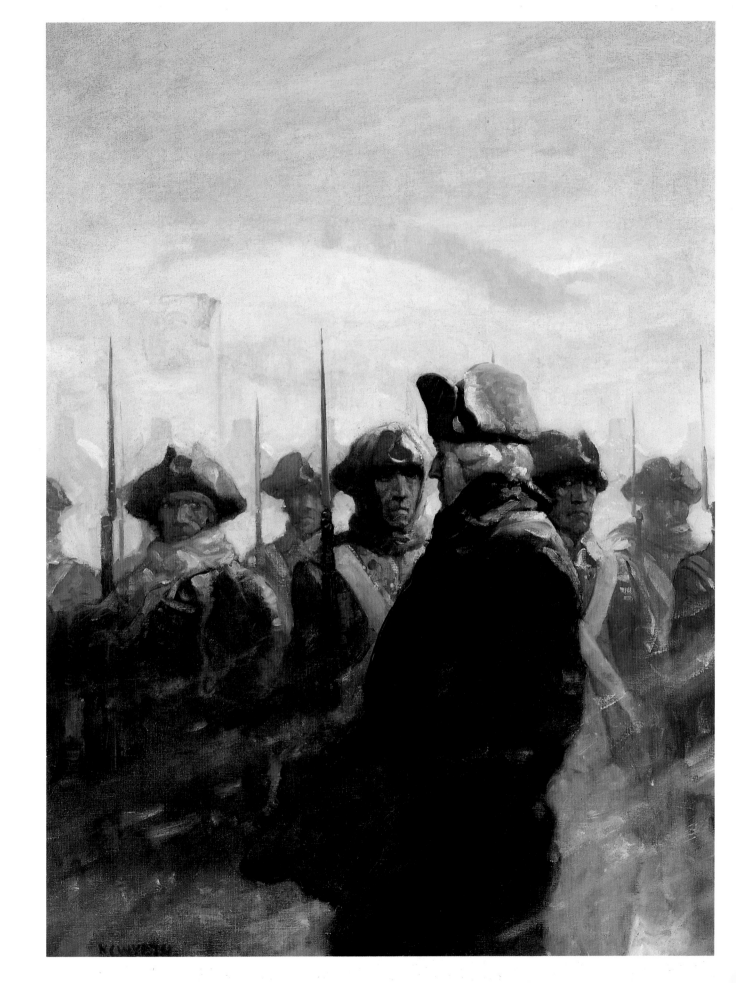

N. C. WYETH

20. *Washington Reviewing His Troops*, 1922

[21]

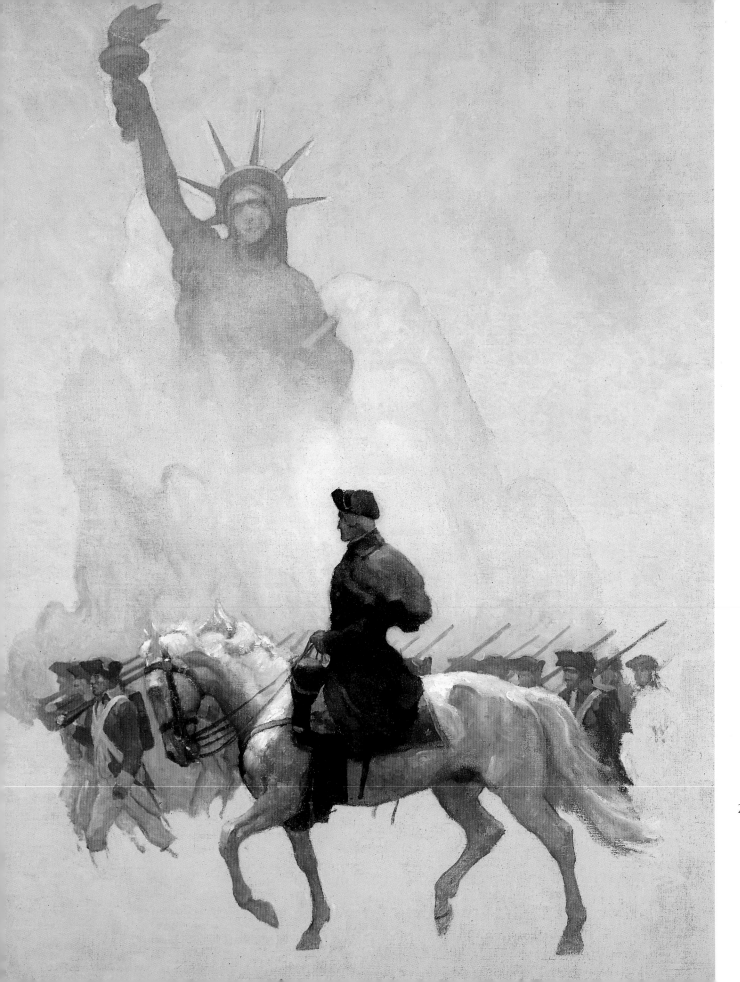

N. C. Wyeth

21. *George Washington*, 1922

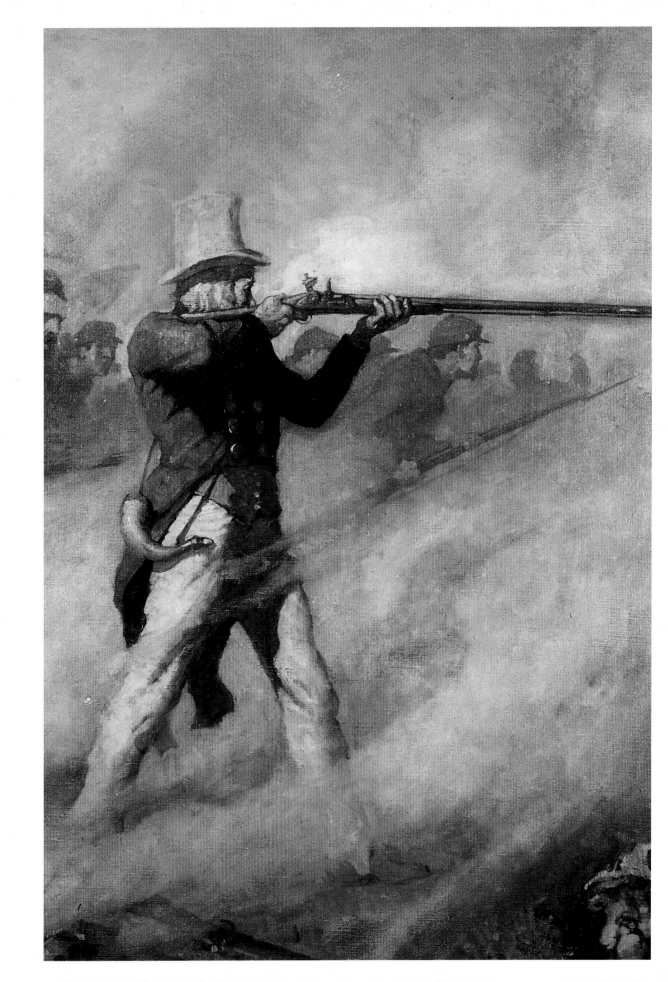

22. *John Burns of Gettysburg,* 1922

N. C. WYETH

23. *The Regular Army Man*, 1922

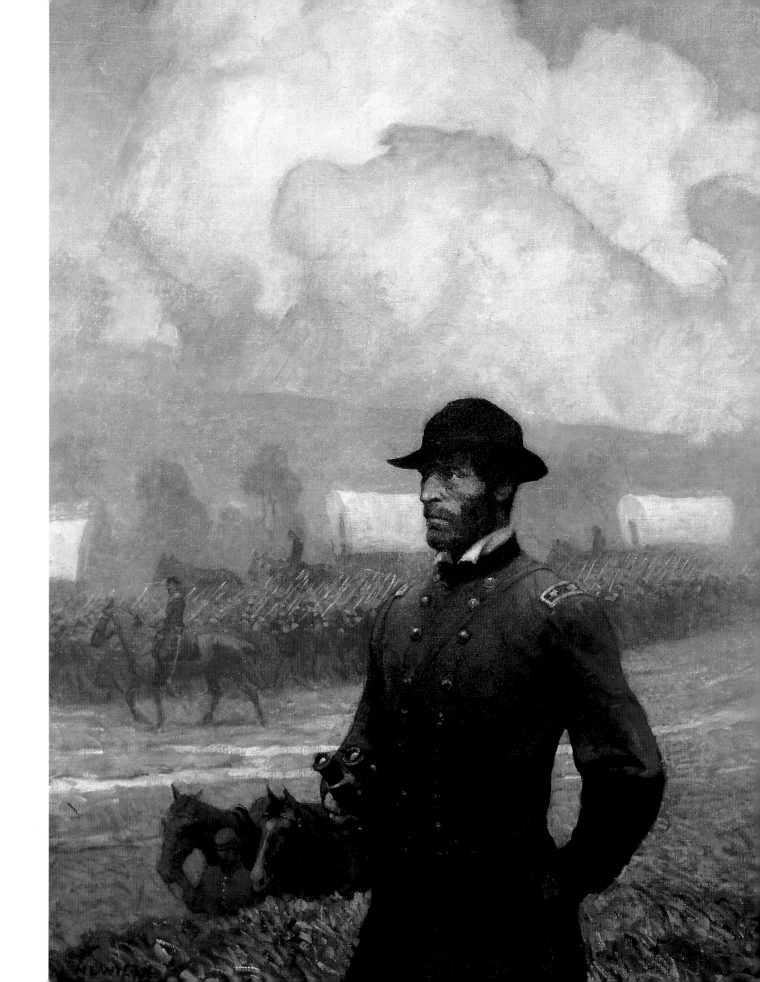

N. C. WYETH

24. *Sherman*, 1922

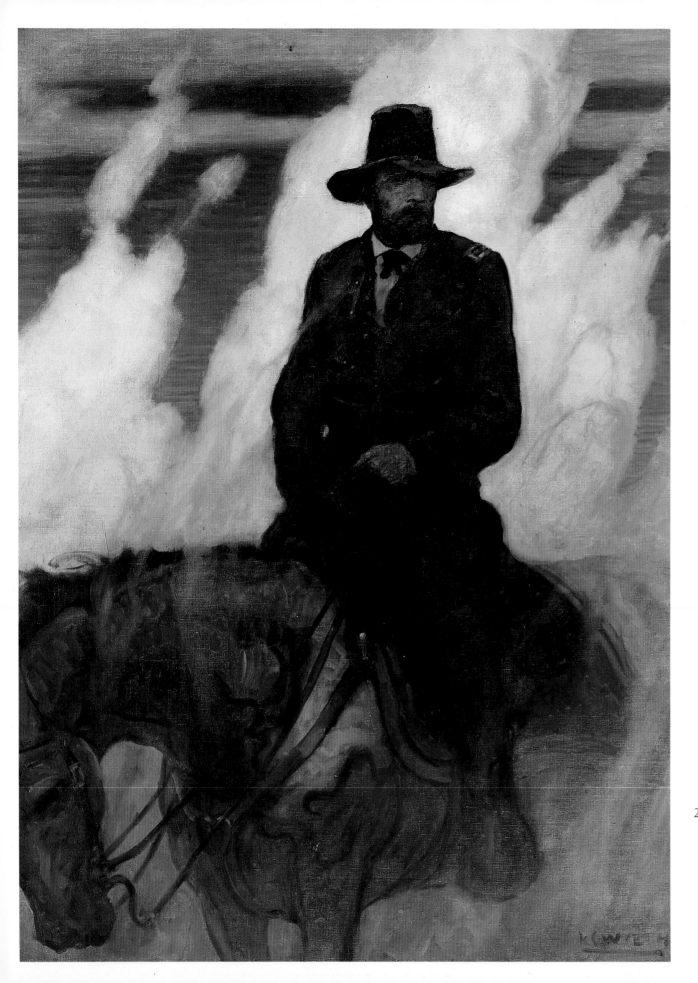

N. C. WYETH

25. *Grant*, 1922

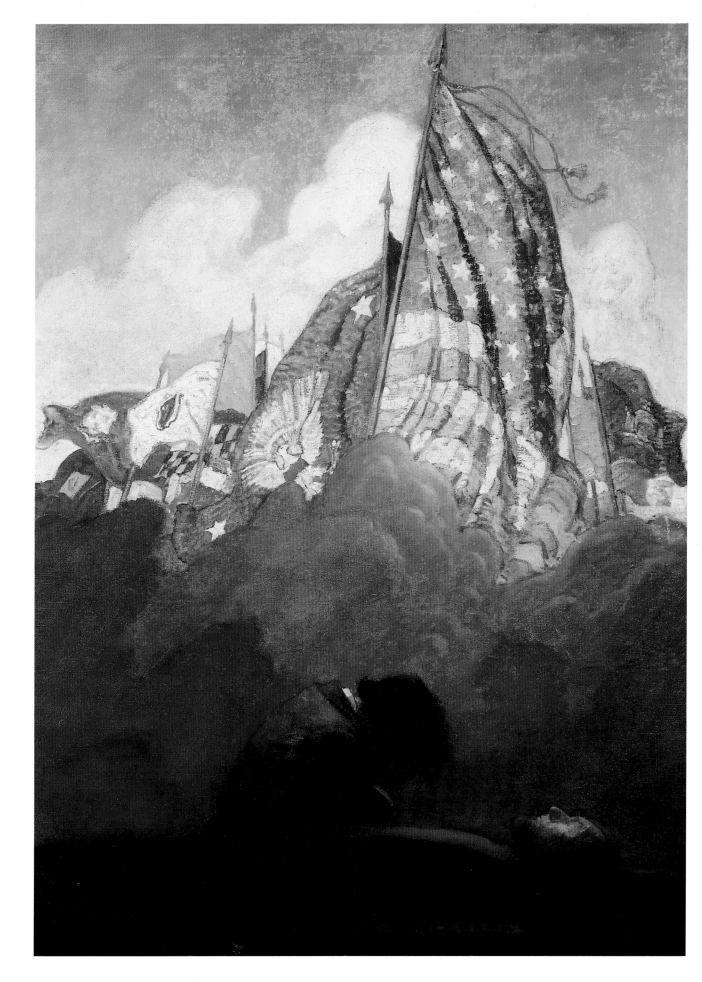

N. C. WYETH

26. *O Captain! My Captain!*, 1922

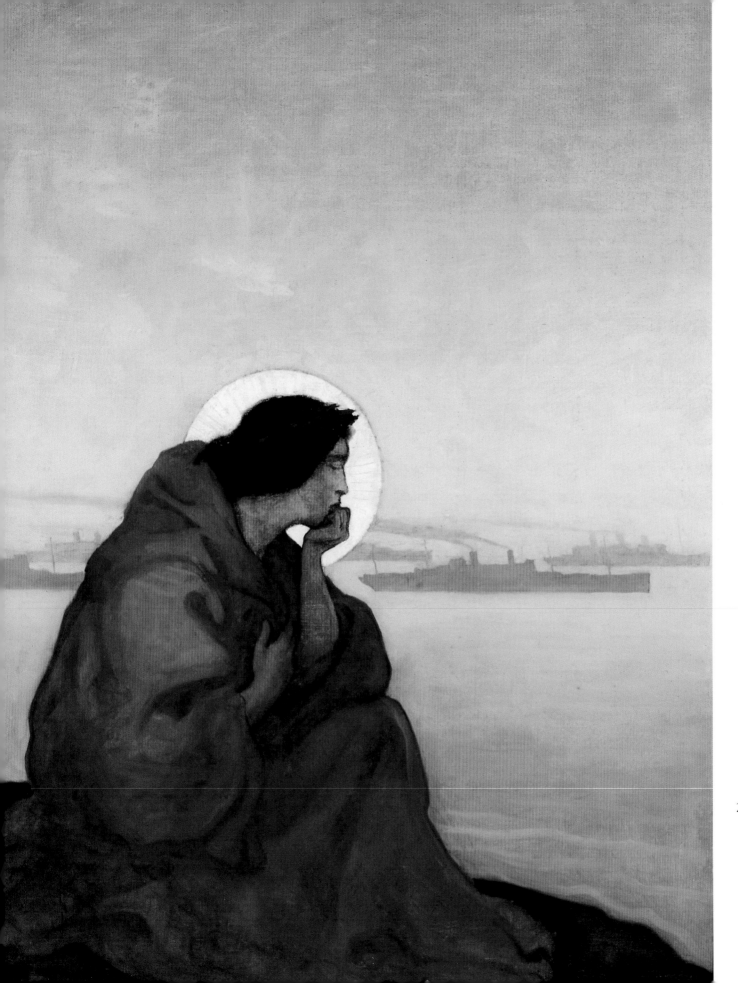

N. C. WYETH

27. *Our Mother*, 1922

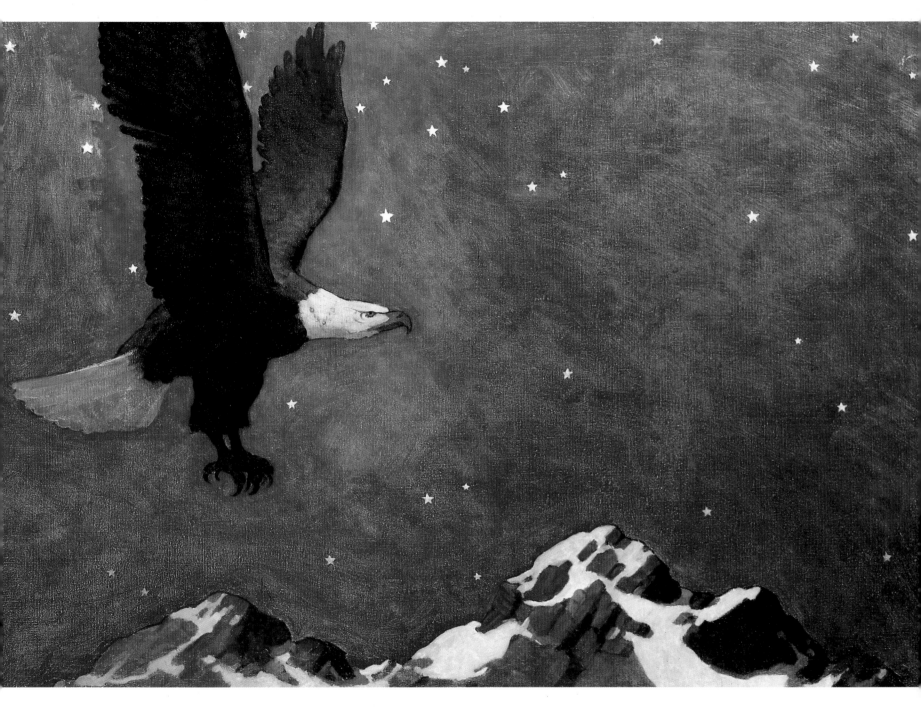

N. C. WYETH

28. *Poems of American Patriotism, Endpaper Illustration*, 1922

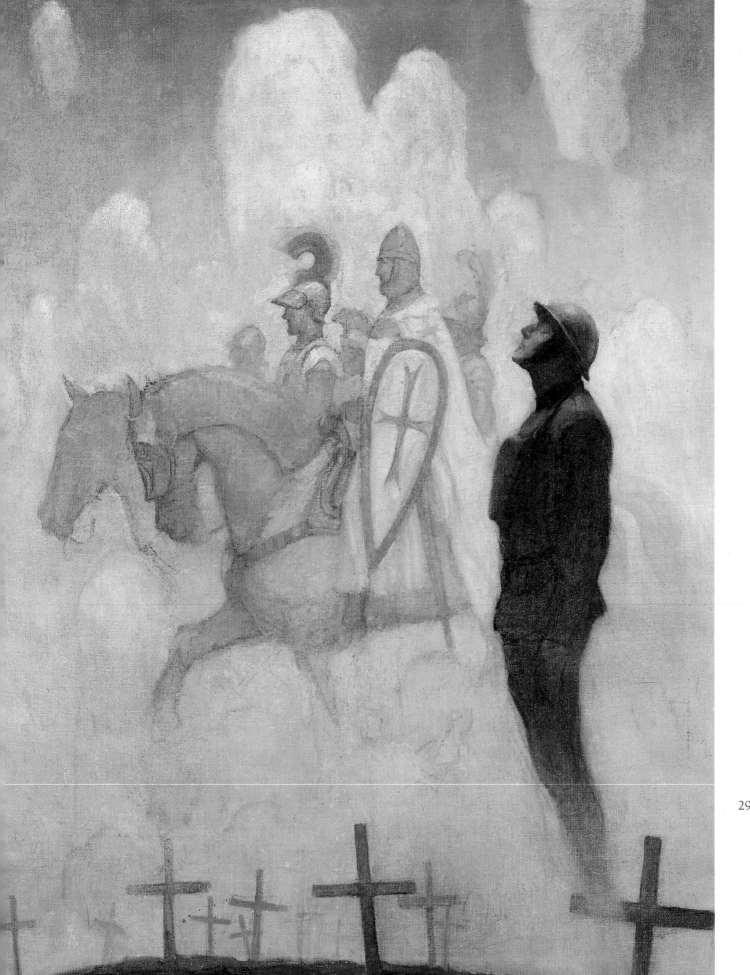

N. C. WYETH

29. *The Unknown Soldier*, 1922

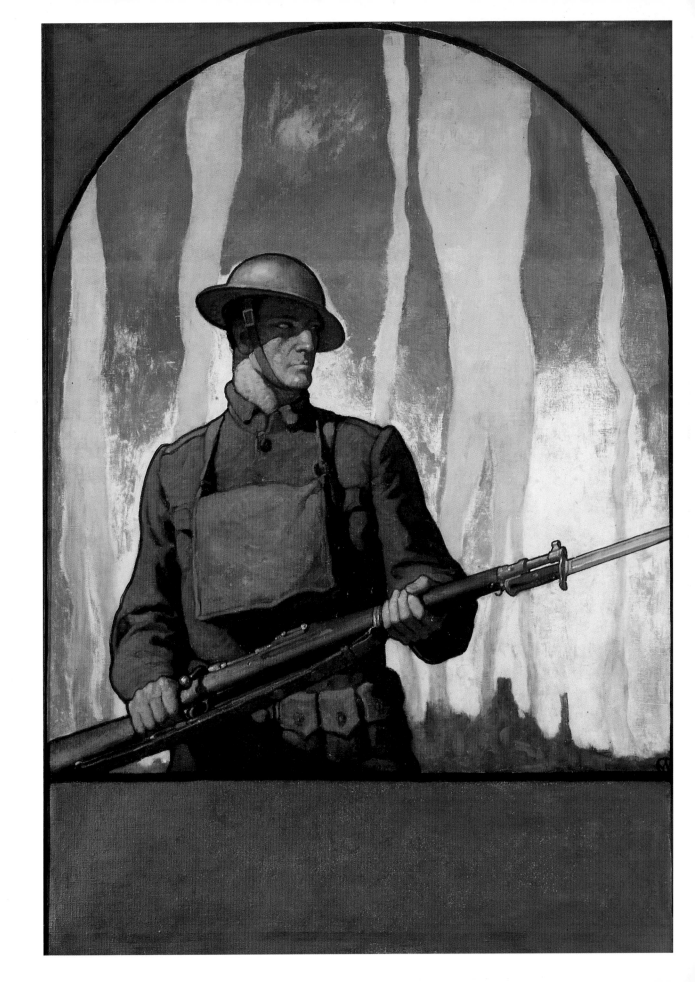

N. C. WYETH

30. *Poems of American Patriotism,*
Cover Illustration, 1922

[31]

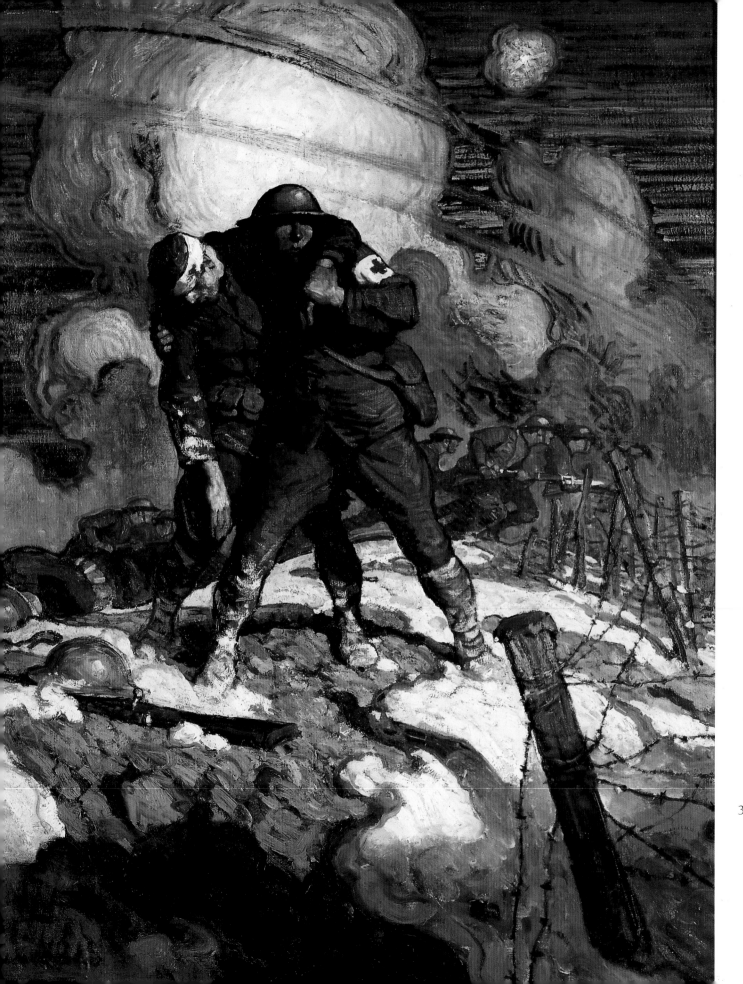

N. C. Wyeth

31. *WWI Poster*, 1918

World War I

\mathcal{P}resident Woodrow Wilson declared war against
Germany on April 2, 1917. Initially, millions of Americans
were of two minds about U.S. involvement in a war that
did not immediately threaten U.S. soil. The overwhelming
sentiment of the country, however, was one of trust in the
government and respect for the presidential office. Once
war was declared, the people—N. C. Wyeth included—
gave their support to the war effort.

In *Twentieth Century and the First, The Dramatic Contrast
of an English Tank in the Streets of Jerusalem* and *The Sign in
the Heavens Which the Judean Shepherds Watching Their Flocks
See This Year,* N. C. conjures a sense of irony, contrasting
the new and the old in a land used to the horrors of war.
N. C. describes them in a letter:

*I have all but completed two pictures (of a set of four) for the
Red Cross Magazine depicting the British occupation of Jerusalem....
[One depicts] a group of shepherds on the hills outside the Holy City,
gazing raptly and with astonishment at an English reconnoitering
airplane. [Another shows] a regiment of British soldiers—or possibly
a "tank" (if I can find out authentically that these modern leviathans
entered the Sacred city) passing under the Arc de Ecce Homo, the
arch under which Christ passed bearing the cross!*[2]

N. C. was also commissioned to produce recruitment posters
and other propagandistic images for the U.S. govenment,
such as *WWI Poster* and *Kamerad!* At first, he was torn about
creating these images, believing that the horror and intensity
of them would compromise his artistic sensitivity, rendering
him unable to pursue his calmer artistic endeavors. His attitude
changed, however, as his research uncovered the atrocities being
committed by the "ruling juggernaut" of Germany. Following
a meeting with a German high official who had fled to the
United States, bringing with him documents and photographs
of the carnage, N. C. became impassioned and reacted by
creating "a reeking cartoon—a bloody commentary on
Emperor William" called *The Abdication of Attila.* In a diatribe
against Kaiser Wilhelm and his reign, N. C. wrote:

*History has been pleased to hold Attila as a symbol of all that is
ferocious and depraved. His brief comparative record as against
the German Kaiser was humane, generous, a suckling babe or
innocent novice in that which we call tyranny and horror.... The
mantle of supreme evil must be lifted from the age-old shoulders
of the King of the Huns and placed upon the living shoulders of
the Emperor of the Boche, the arch-tyrant of history!*[3]

Both the imagery and paint handling are unusual for
N. C. Wyeth in *The Abdication of Attila.* The quick sketchy
slashes of paint convey the passion of his emotion with
sheer energy and not his usual controlled detail, as if he
were purging himself of this hideous imagery.

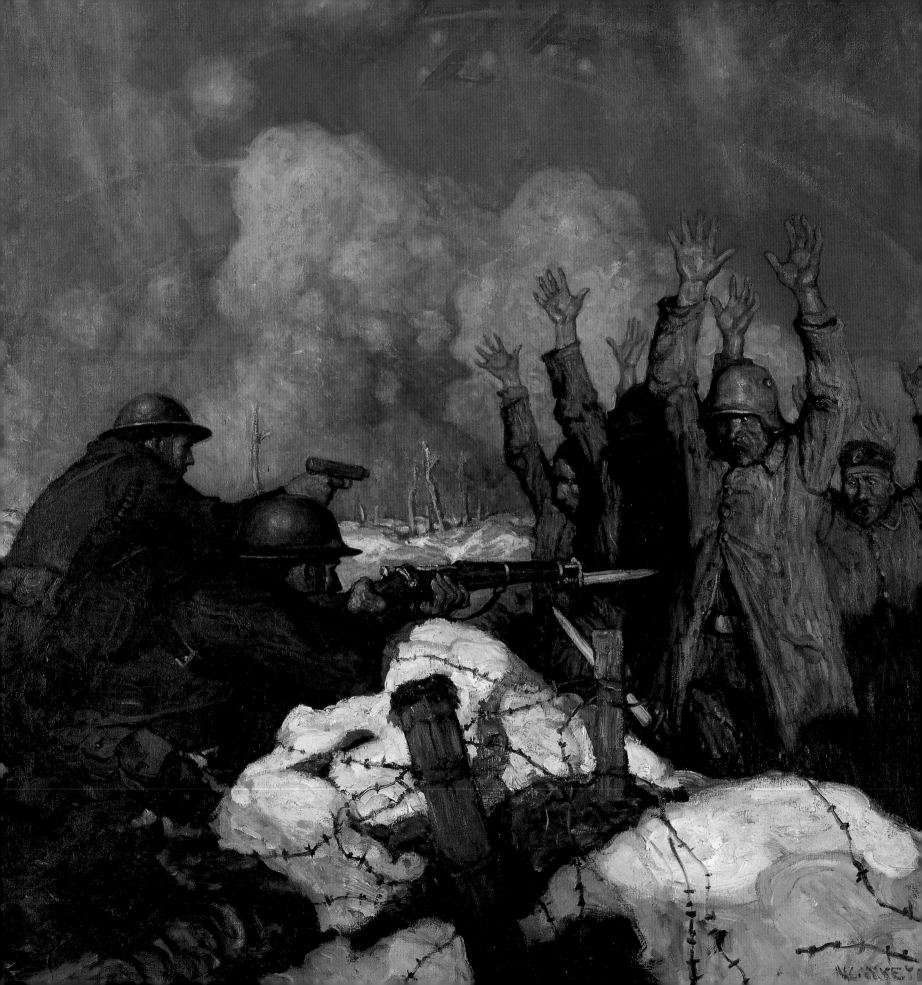

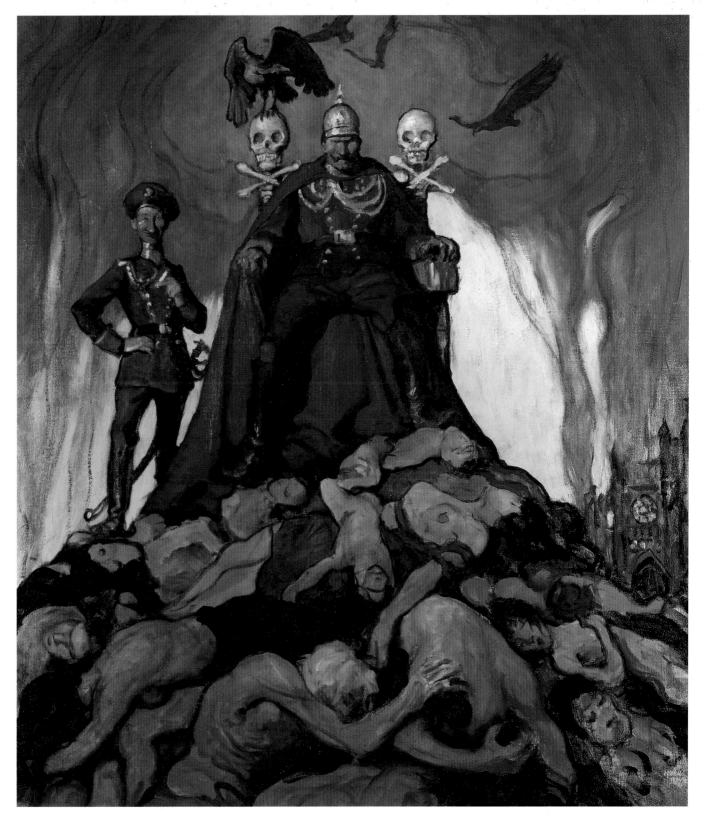

N. C. WYETH

32. *Kamerad!*, 1919

N. C. WYETH

33. *The Abdication of Attila*, 1917

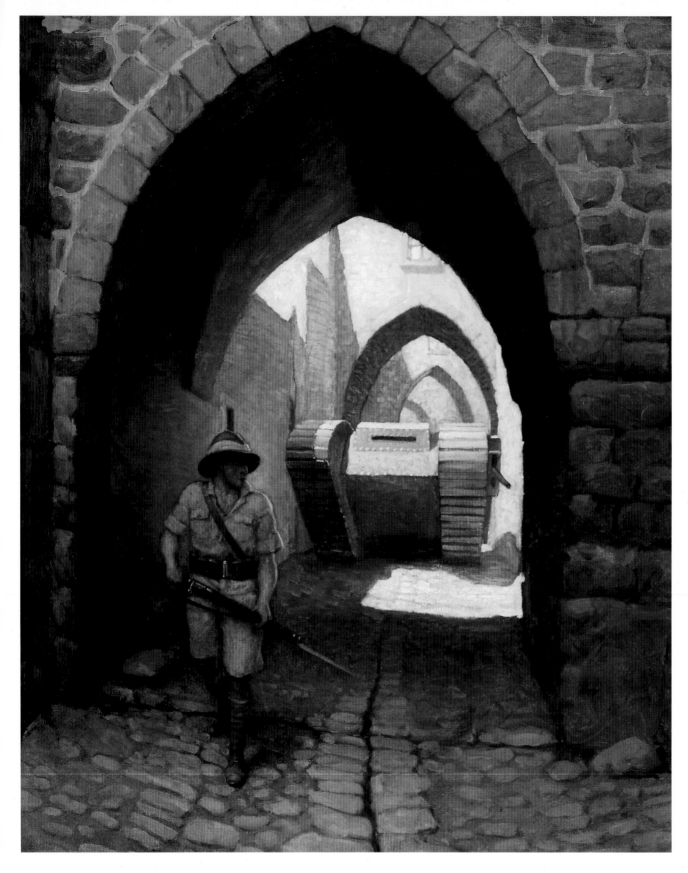

N. C. WYETH

34. *Twentieth Century and the First, The Dramatic Contrast of
an English Tank in the Streets of Jerusalem,* 1918

N. C. WYETH

35. *The Sign in the Heavens Which the Judean Shepherds
Watching Their Flocks See This Year,* 1918 ▶

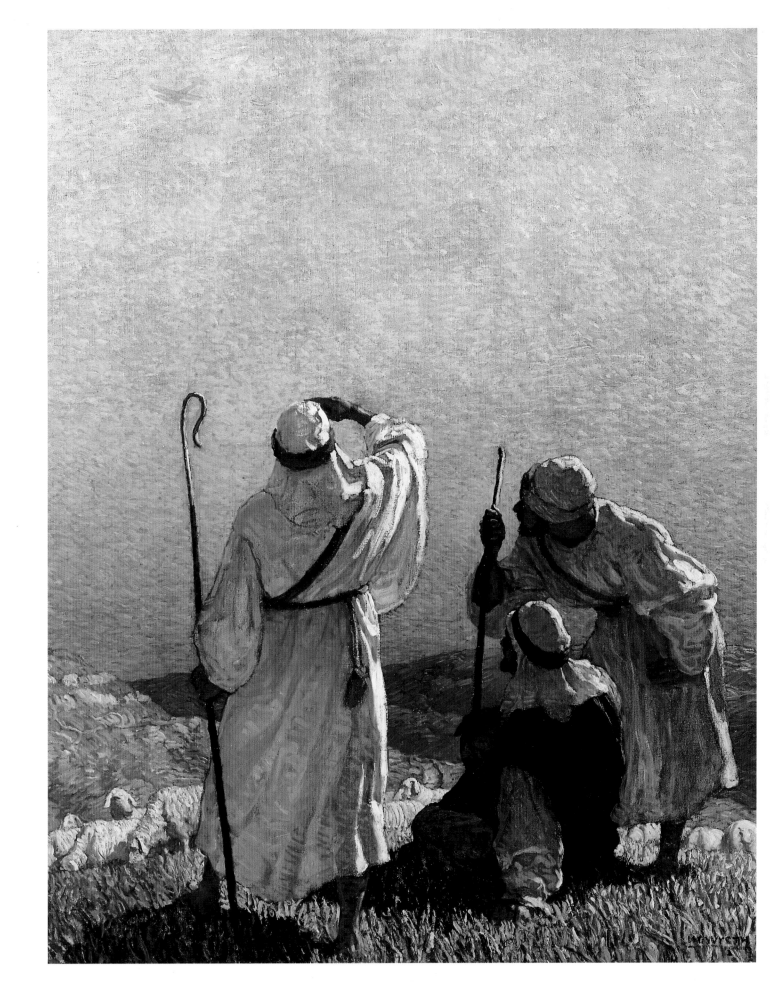

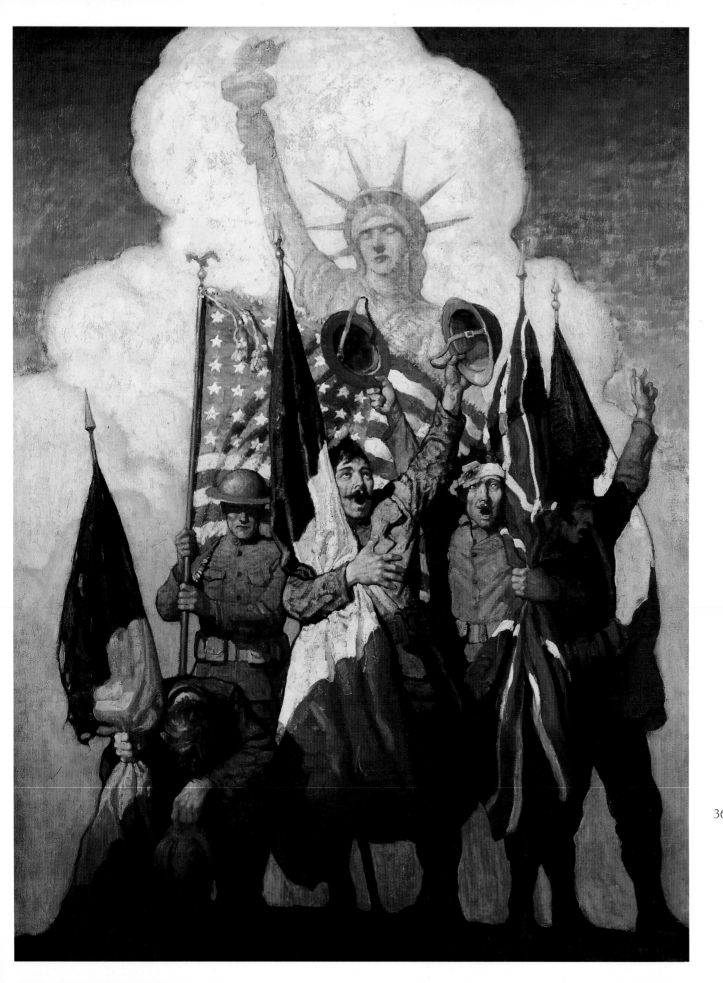

N. C. Wyeth

36. *The Victorious Allies*, c. 1918

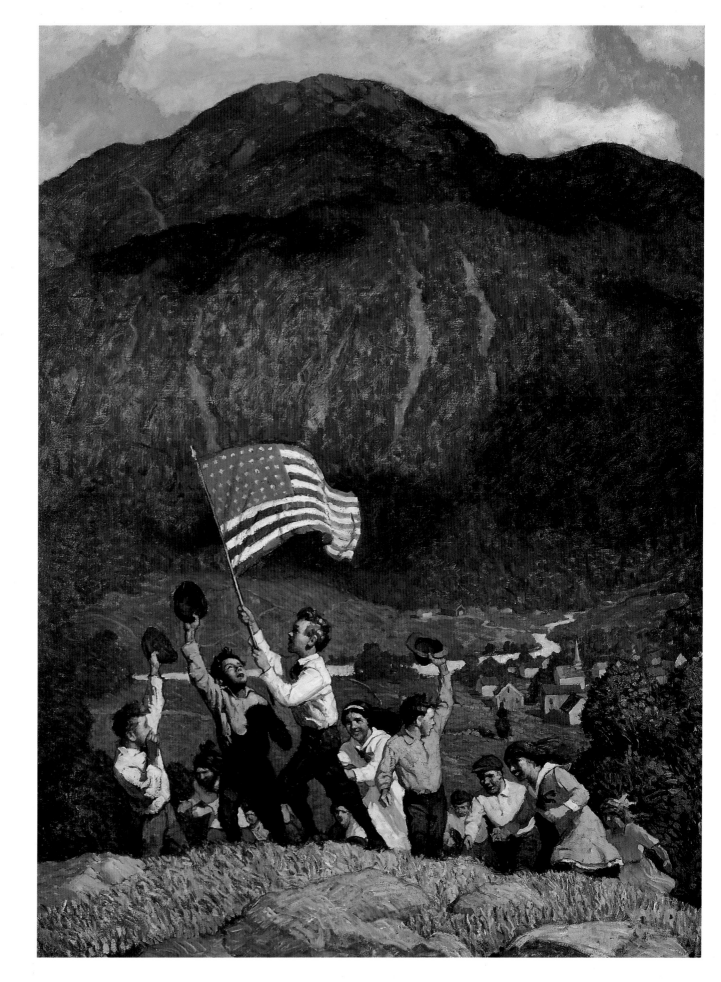

N. C. WYETH

37. *America's Greatest Wealth Is in Her Healthy Children,* c. 1925

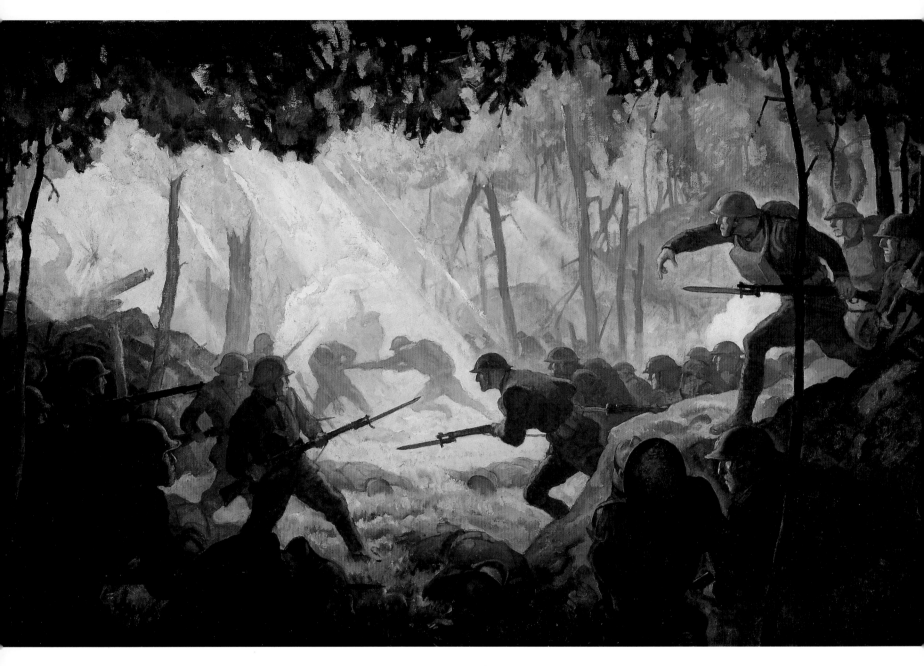

N. C. WYETH

38. *It was after this attack that the High Command published to the German army: "The moral effect of our own gunfire cannot seriously impede the advance of the American Infantry,"* 1930

World War II

Twenty-three years had passed from Armistice Day to the bombing of Pearl Harbor. The country tried to remain neutral during the early stages of the war, but reacted to the attack on Pearl Harbor with a fury. The moment American blood was shed, there was no question of neutrality. Those who spoke against the United States involvement following December 7, 1941, faced being labeled "Communist" or "Nazi" and were ostracized from society. Among those who preached "isolationism" was Charles Lindbergh, who consequently went from being America's hero to a political pariah, essentially for stating that during his government-sanctioned visits to German air bases and factories he witnessed that their technology had surpassed that of the U.S.

"Patriotism" may be said to have been at its height at this time, and that attitude is reflected in the work of N. C. Wyeth. The American flag, Uncle Sam, and victory for the brave fighting troops were the prevalent images, reflecting the idealized society that America needed to believe in while loved ones fought and died overseas. On both sides of this war, charismatic leaders spoke eloquently and passionately to their followers, filling hearts with pride and with a desire to assist in any way possible. Franklin D. Roosevelt and Winston Churchill were the voices heard in the hearts of Americans, including N. C. Wyeth. He wrote in September 1945 to his daughter, Henriette, "My head still rings with the impressive and exciting broadcast of Churchill's! He laid out the whole diabolical pattern in such heroic terms that at once lifted everything into sublime and portentous music."[4]

N. C. took the words and emotions of these leaders and created the images that would urge the nation on to victory. These images are exemplified by works such as *Amateurs at War: The American Soldier in Action*, *We're On Our Way*, and *Soldiers of the Soil*.

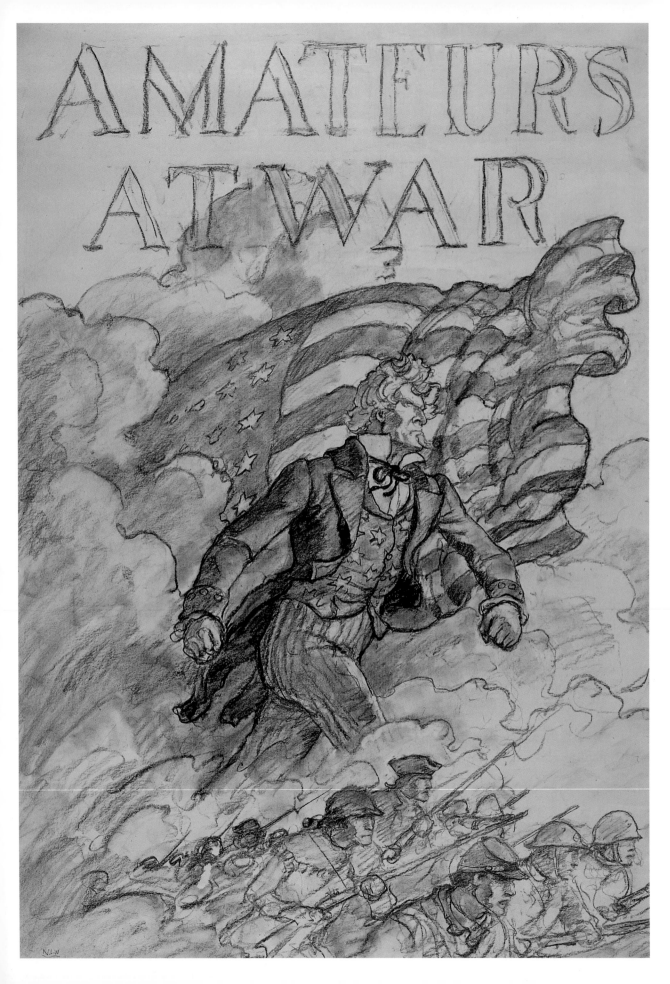

39. *Amateurs at War: The American Soldier in Action*, 1943

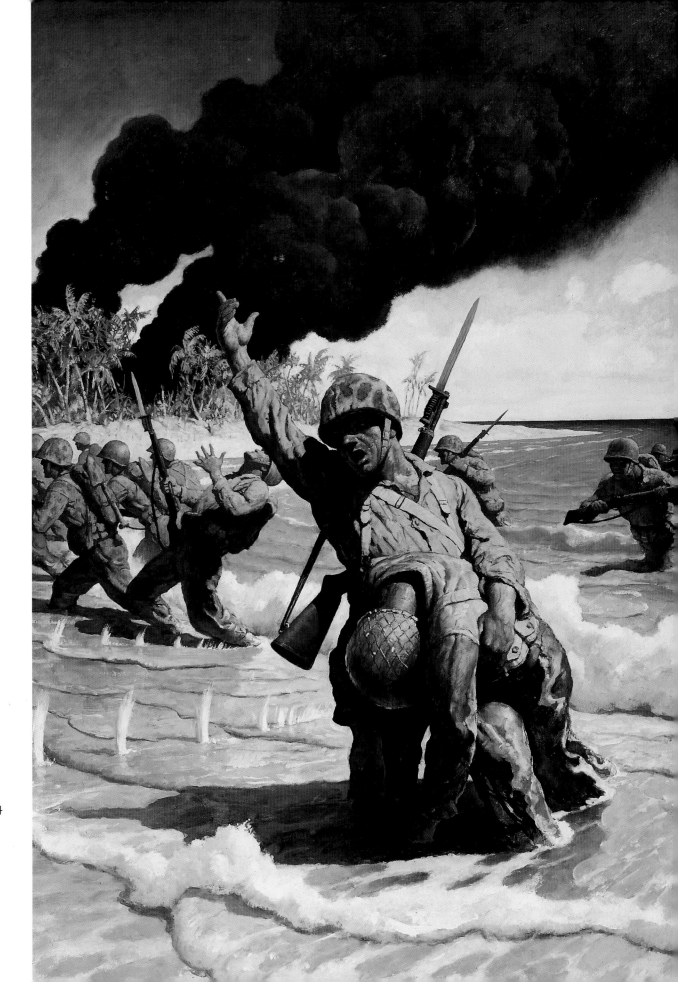

N. C. WYETH

40. *Marines Landing on the Beach*, 1944

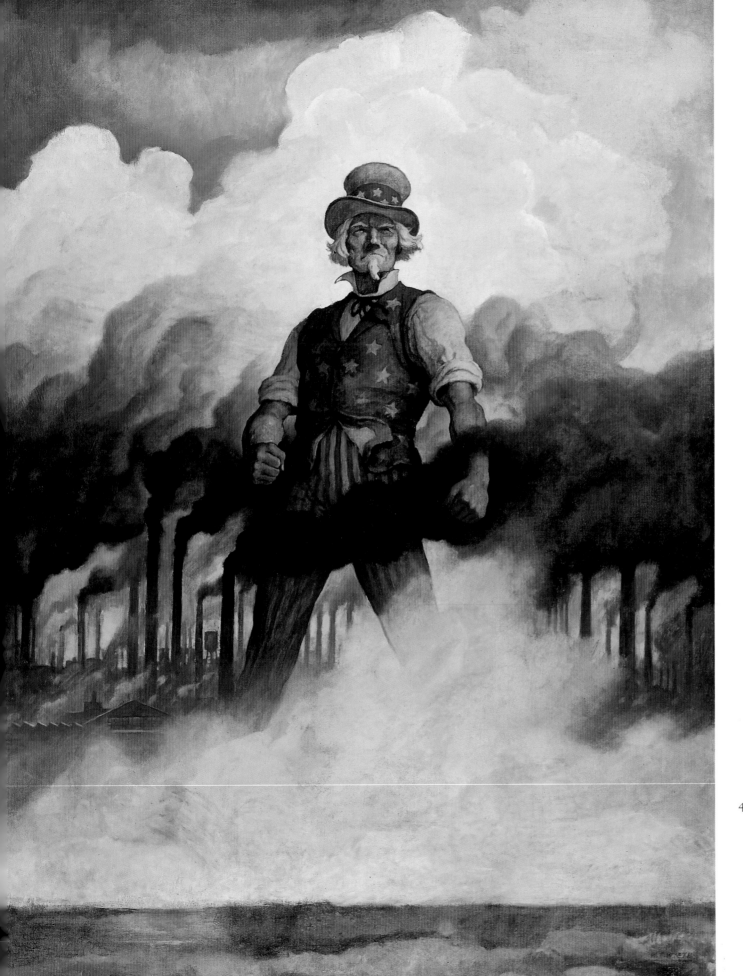

N. C. WYETH

41. *We're On Our Way, 1944*

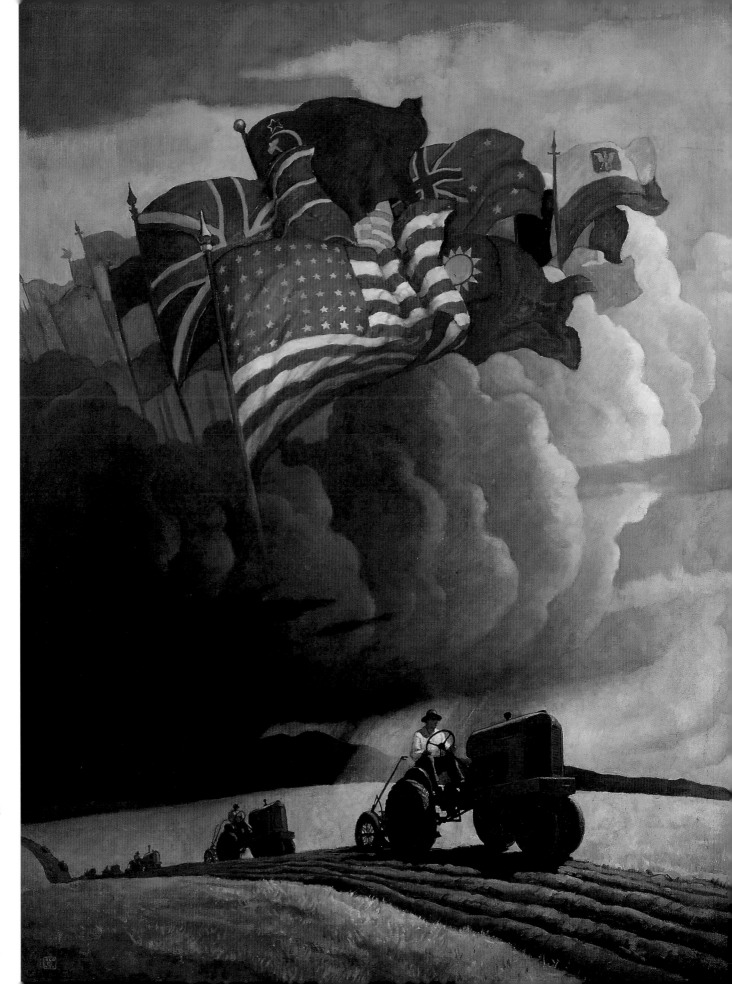

N. C. WYETH

42. *Soldiers of the Soil*, 1942

N. C. WYETH

43. *The Home Coming—
composition drawing,*
1944

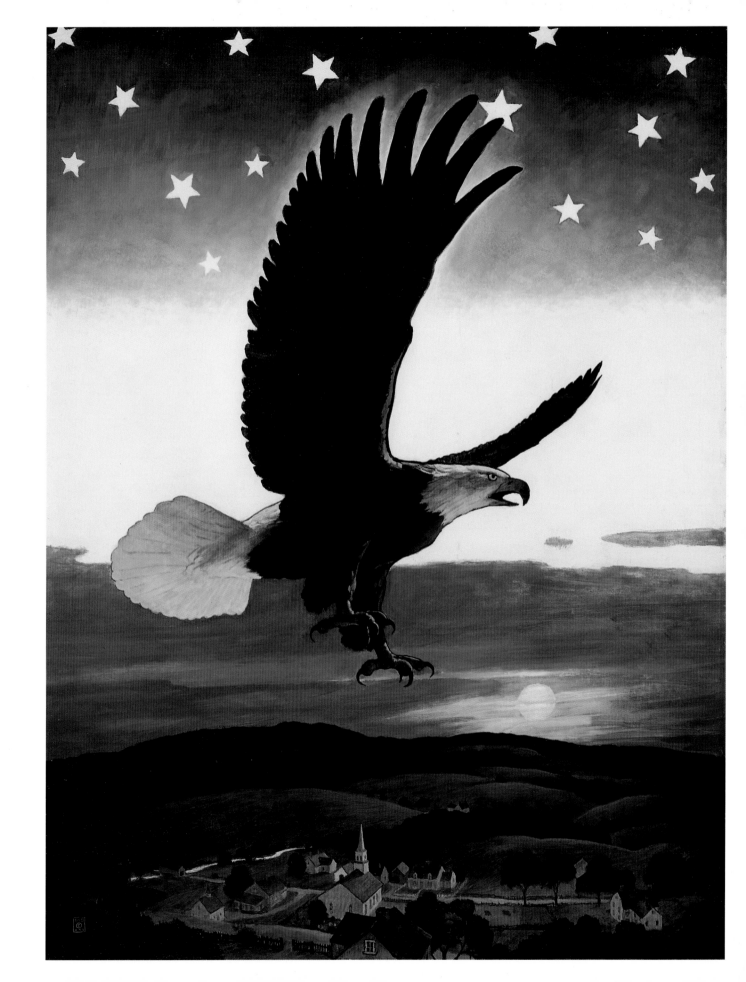

N. C. Wyeth

44. *Our Emblem*, c. 1944

JAMES BROWNING WYETH

Portraiture as a genre has retained its importance despite the invention of photography. Portrait artists of quality do not capture a moment in time but an essence of the person, encompassing the likeness as well as the spirit of the sitter. As the country has matured, so too has the concept of the portrait. The beginning of the twentieth century in America could be characterized by innocence, with an optimism that enabled our society to see the best in its leaders. Assassinations, ill-fated wars, and particularly the governmental subterfuge of Watergate led to a questioning, and often doubting, society that saw with more clarity an unromanticized "reality." The work of James Wyeth embodies this societal trend away from idealism, and it has sometimes carried the charge of being "unflattering." Alternately called a "genuine master of the portrait," James captures the indefinable quality that makes an effective and affective portrait. The creation of a portrait enables, actually demands that James delve into the persona of the sitter, spending hours observing the person, to the point that the artist absorbs the sitter's "quality" by osmosis, mingling it with his own. His most vivid portraits are of people he knows well, childhood friends (as in *Draft Age*), or people he has spent a great deal of time getting to know (JFK's sister Jean Kennedy Smith). *Time* magazine recognized his talents and commissioned him to create portraits of two Presidents for special issues of the magazine (Thomas Jefferson for the celebration of the Bicentennial issue, and Jimmy Carter as Man of the Year 1977).

The posthumous portrait of President John F. Kennedy presented a great challenge to James. The background research included viewing hours of JFK film footage, letters from the President's archives, photos by his close friends, and most significantly, extensive access to the rest of the family leading to lifelong friendships. James sensed immediately the "Kennedyness" that would be essential for him to create a successful portrait. He spent hours with Robert and Edward Kennedy, sketching study after study of them in action, attempting to distill from them an accurate picture of their brother. He then experimented with one composition in which JFK was walking with his hands in his pockets; however the "quality" eluded him and this painting was destroyed before it was finished. The breakthrough came while on the campaign trail with Edward. In a Providence, Rhode Island, hotel room, James witnessed the Senator talking with his advance man, one eye completely fixed on him while the other was focused on a distant time and place. This congenital Kennedy look was described in a *Look* magazine article from April 2, 1968, as "the calculating gaze that masks the political mind forever diverted to some scene still unplayed."[5]

The final portrait shows a pensive-looking JFK, his hand up tapping his teeth with his finger, an unconscious habit when he was deep in thought. The portrait was controversial even among family members. James had not idealized the fallen President, and in fact had presented all too realistic an image even for those who knew him well. His brother Robert reportedly felt uneasy about this depiction, and said it reminded him of the President during the Bay of Pigs invasion. Despite the controversy, this image of JFK has been reproduced extensively and was selected to become the national stamp of Ireland in 1988.

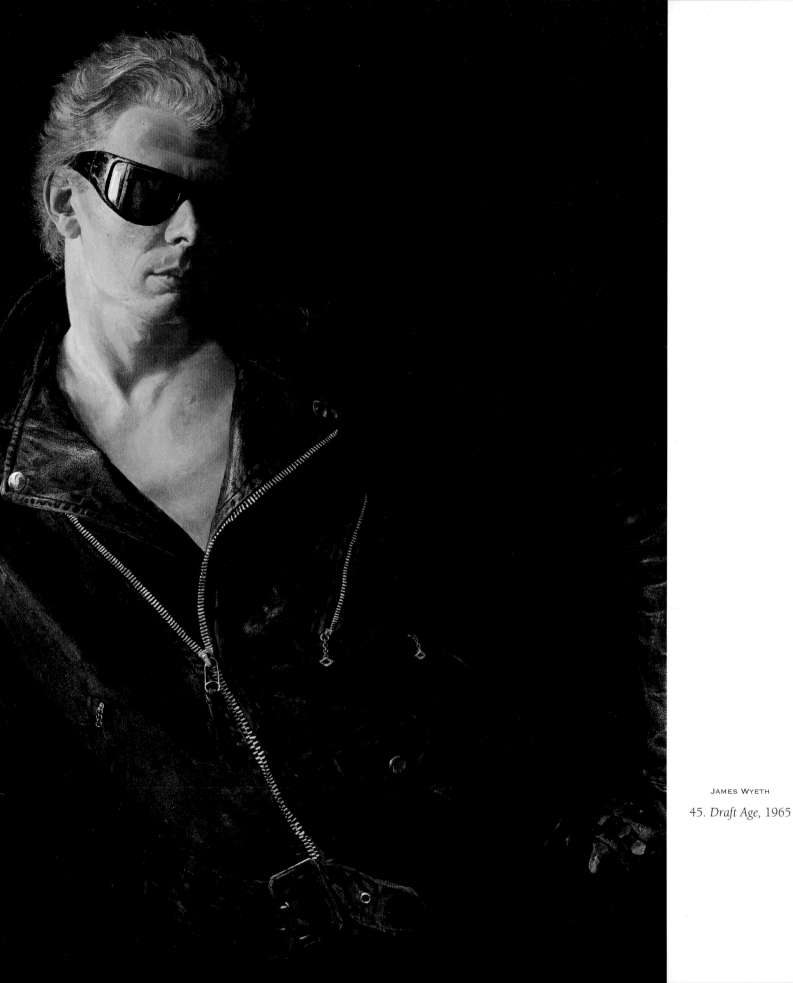

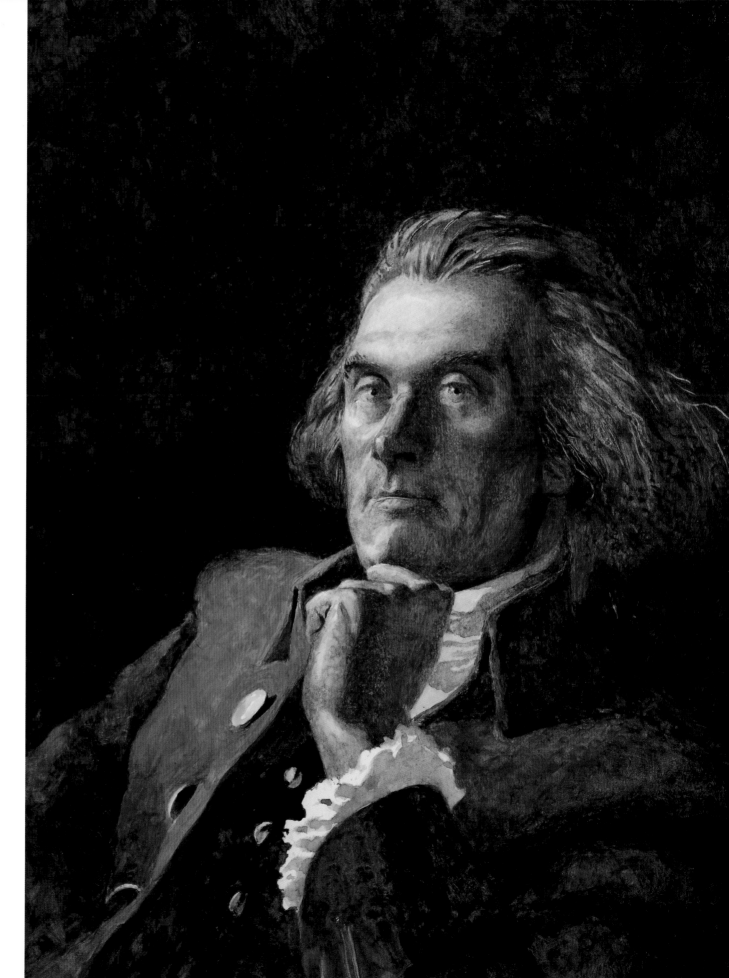

JAMES WYETH

46. *Portrait of*
Thomas Jefferson, 1975

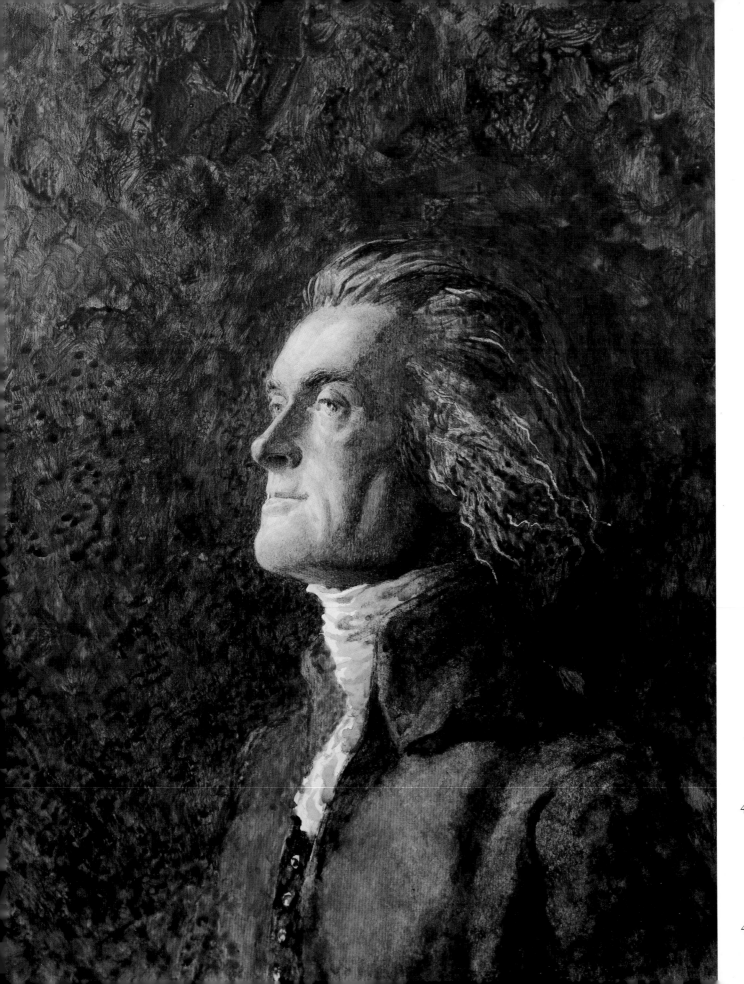

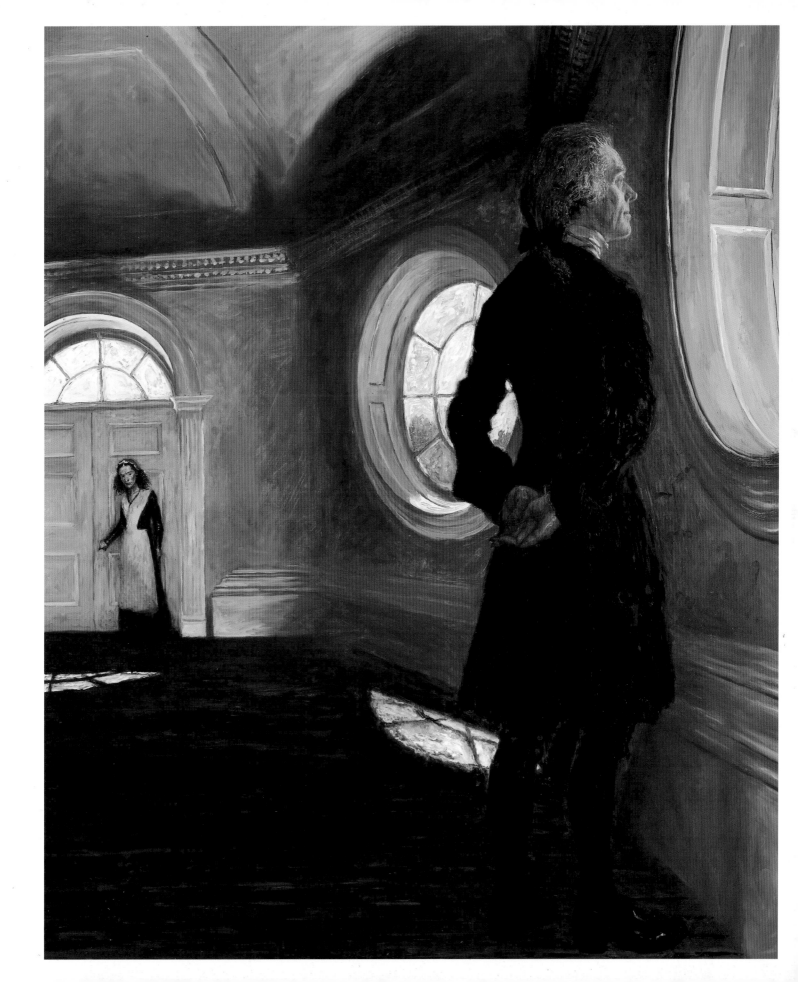

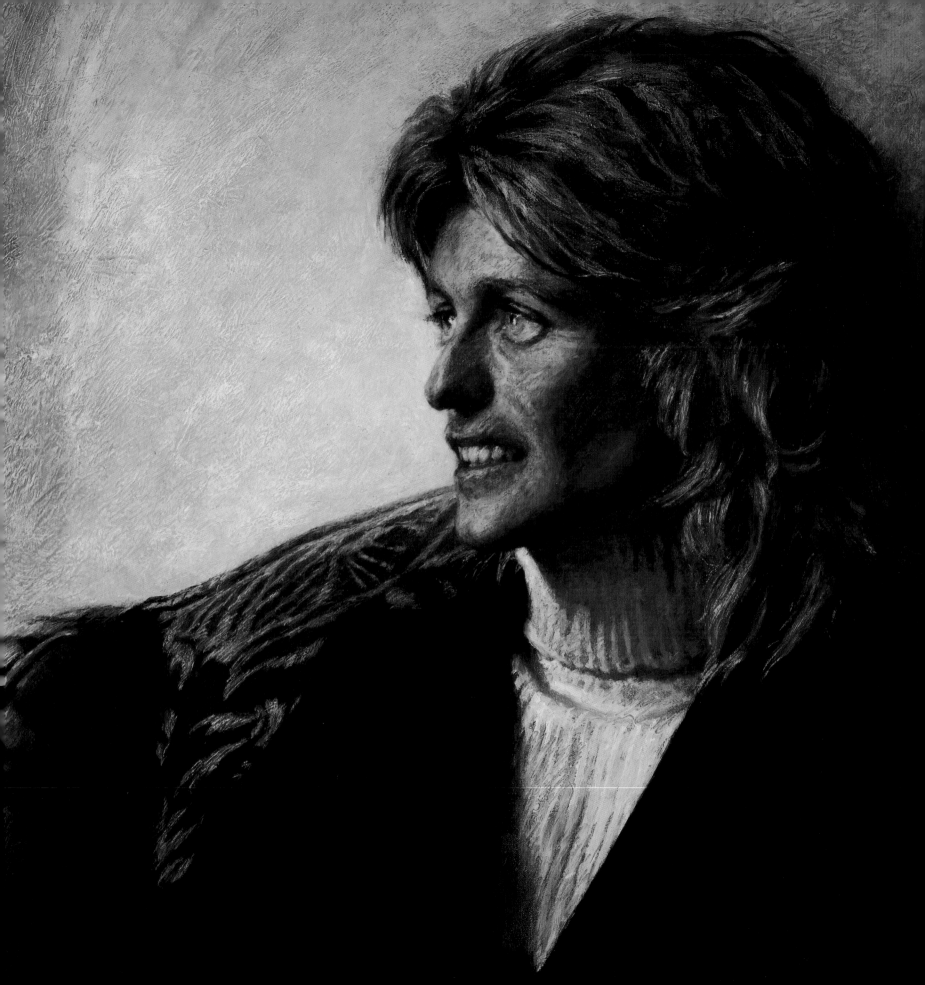

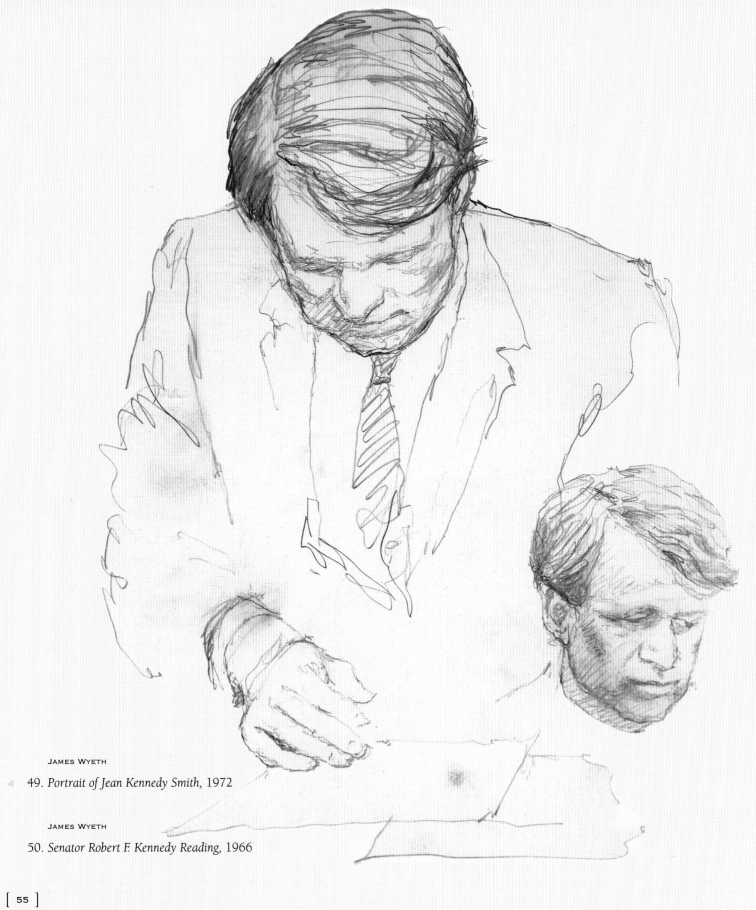

JAMES WYETH

49. *Portrait of Jean Kennedy Smith,* 1972

JAMES WYETH

50. *Senator Robert F. Kennedy Reading,* 1966

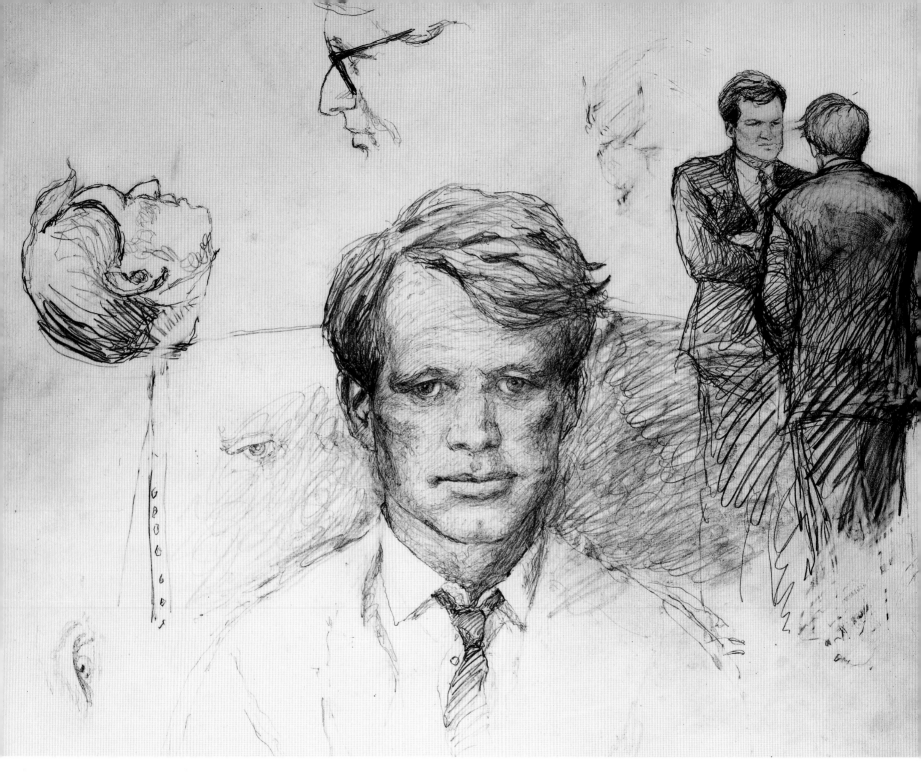

JAMES WYETH

51. *Senator Robert F. Kennedy and Senator Edward M. Kennedy,* c. 1966

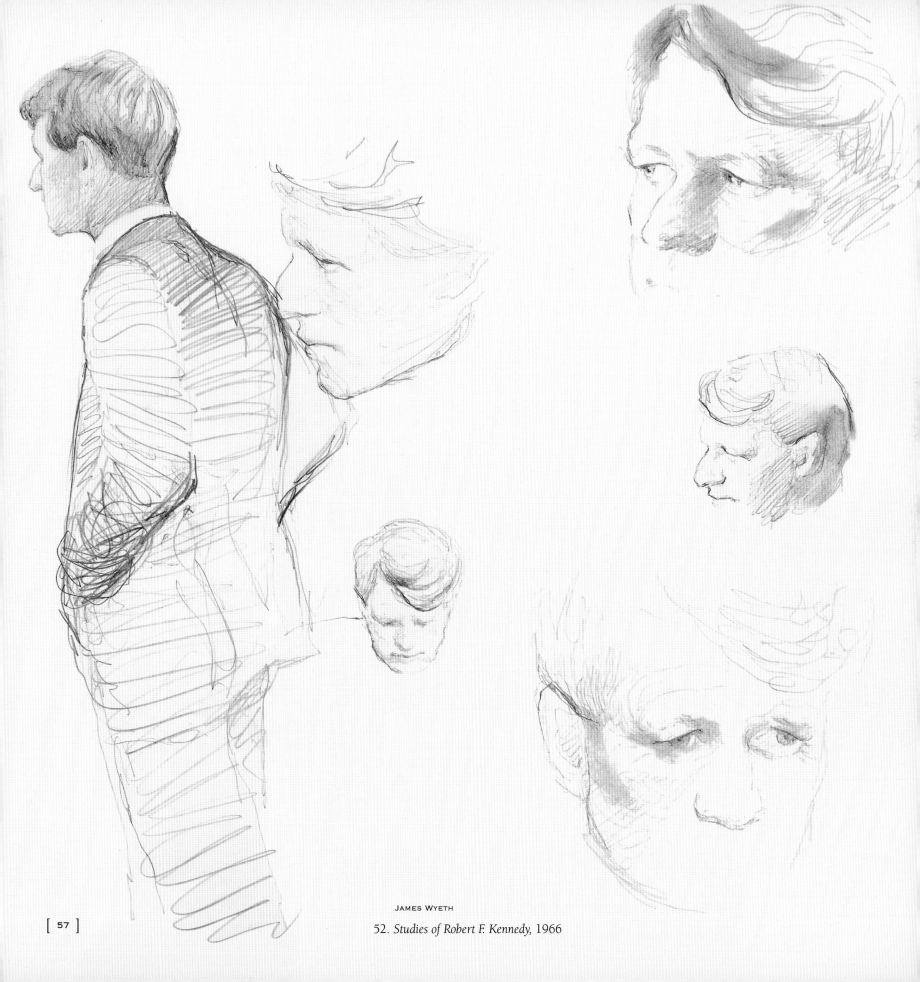

JAMES WYETH

52. *Studies of Robert F. Kennedy*, 1966

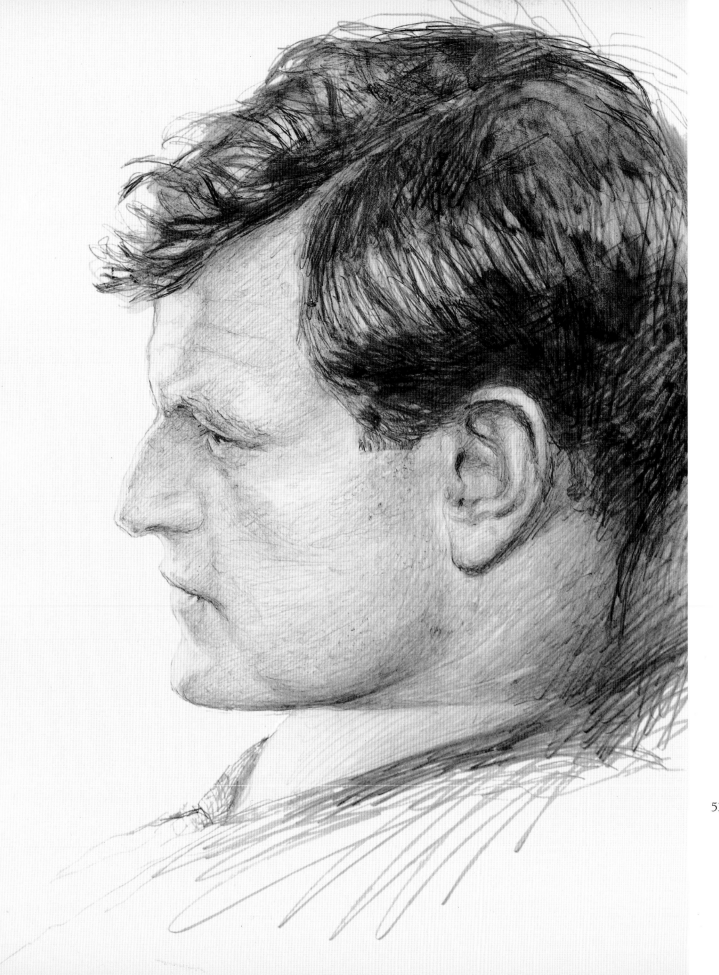

JAMES WYETH

53. *Senator Edward M. Kennedy— study,* c. 1966

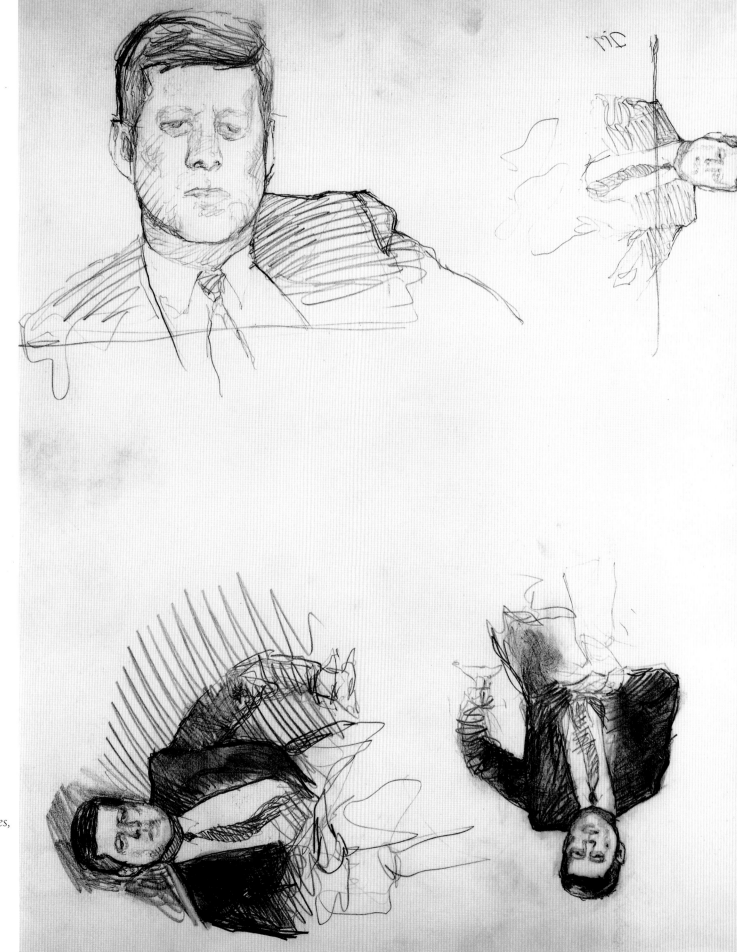

JAMES WYETH

54. *Portrait of JFK—*
study with four images,
1966

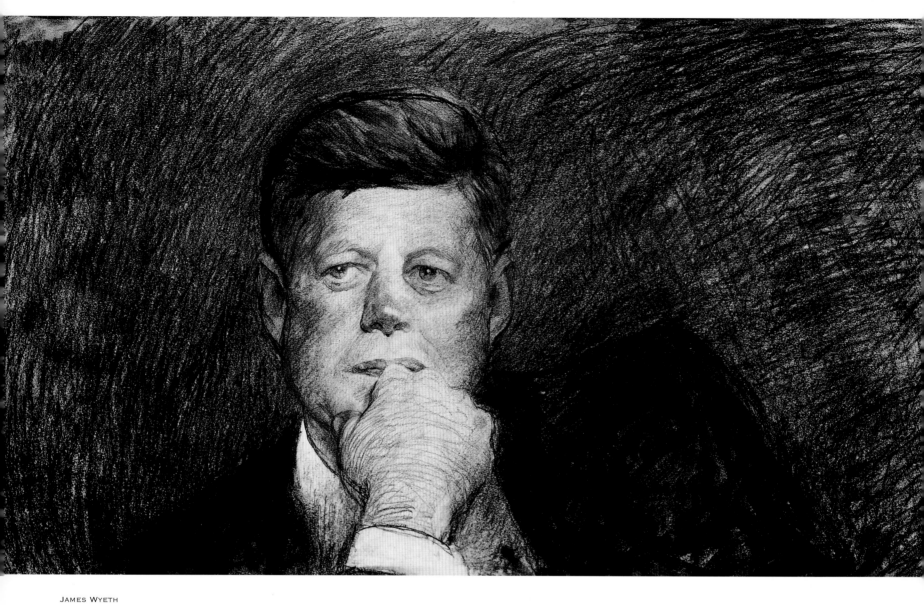

JAMES WYETH

55. *John F. Kennedy, 1966*

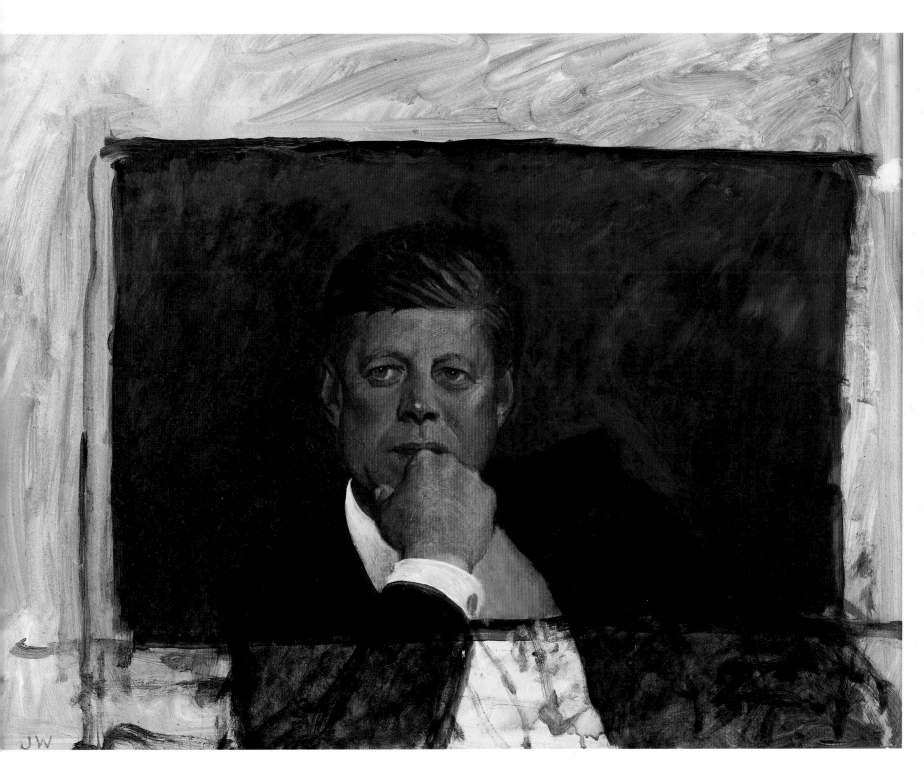

JAMES WYETH

56. *Portrait of President John F. Kennedy—oil study, 1967*

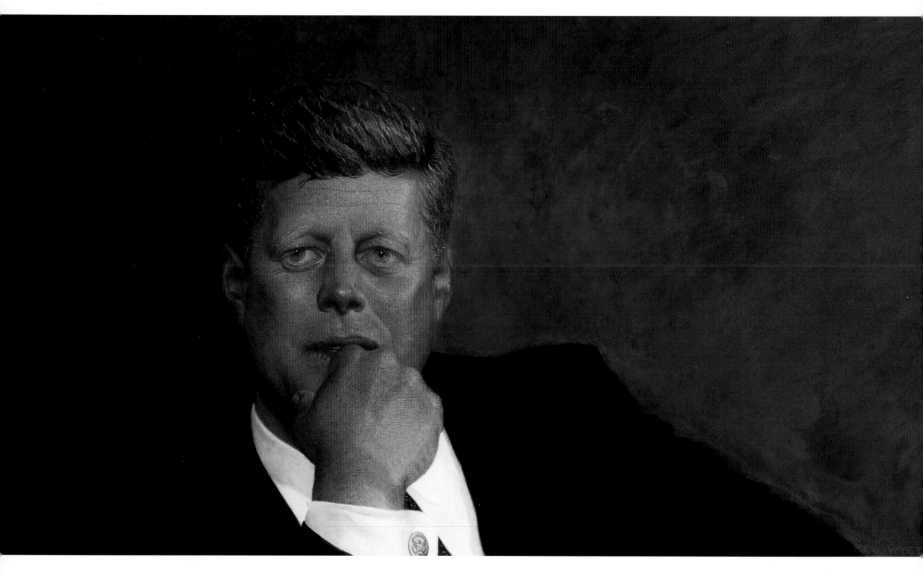

JAMES WYETH

57. *Portrait of President John F. Kennedy*, 1967

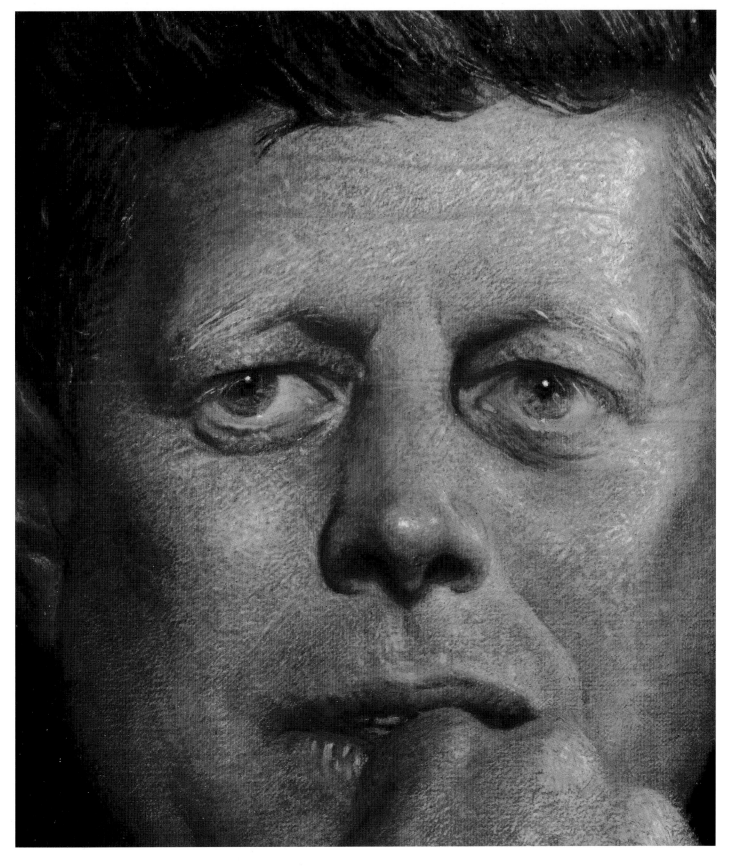

JAMES WYETH

58. Detail—*Portrait of President John F. Kennedy, 1967*

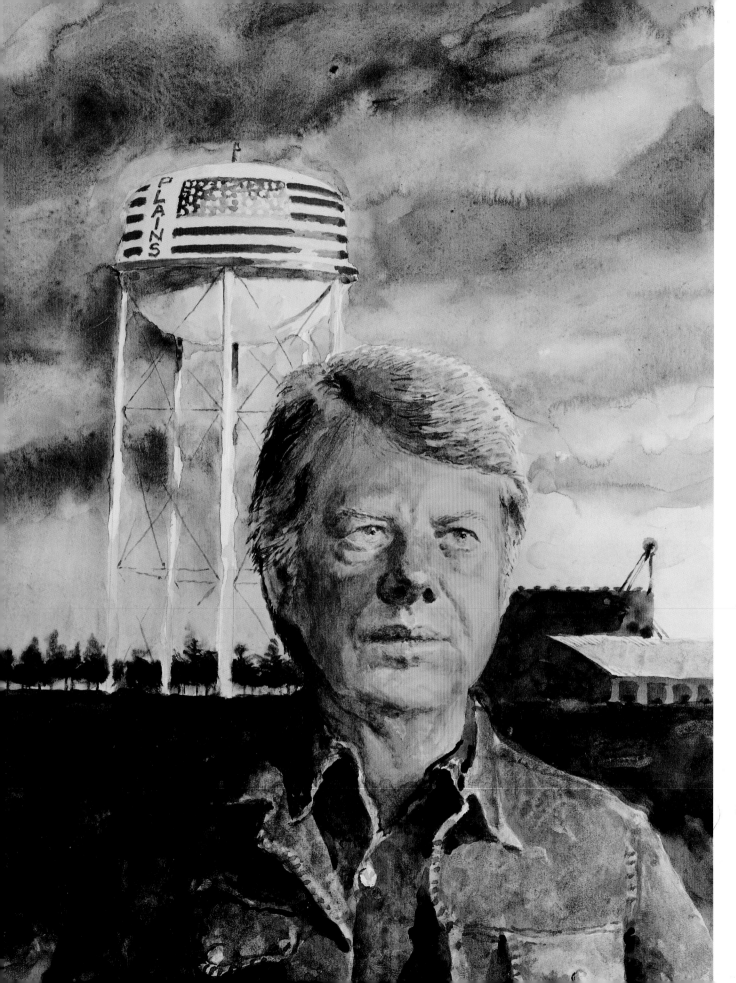

JAMES WYETH

59. *Jimmy Carter*, 1976

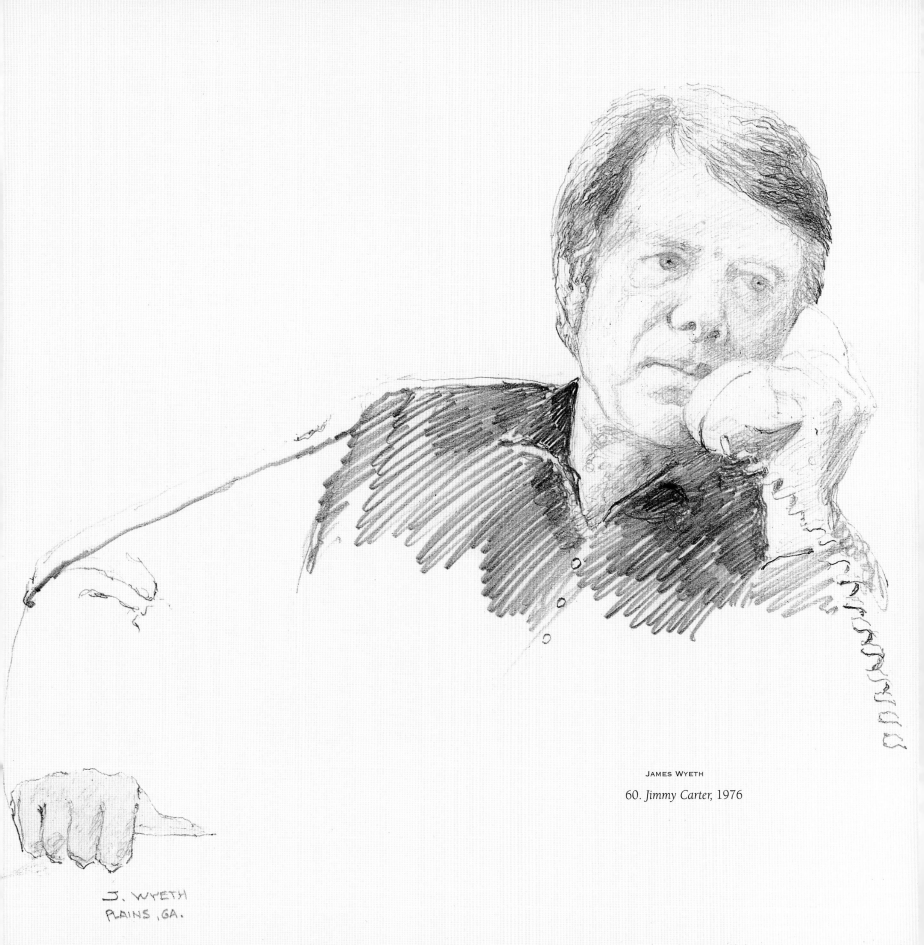

JAMES WYETH

60. *Jimmy Carter, 1976*

J. WYETH
PLAINS, GA.

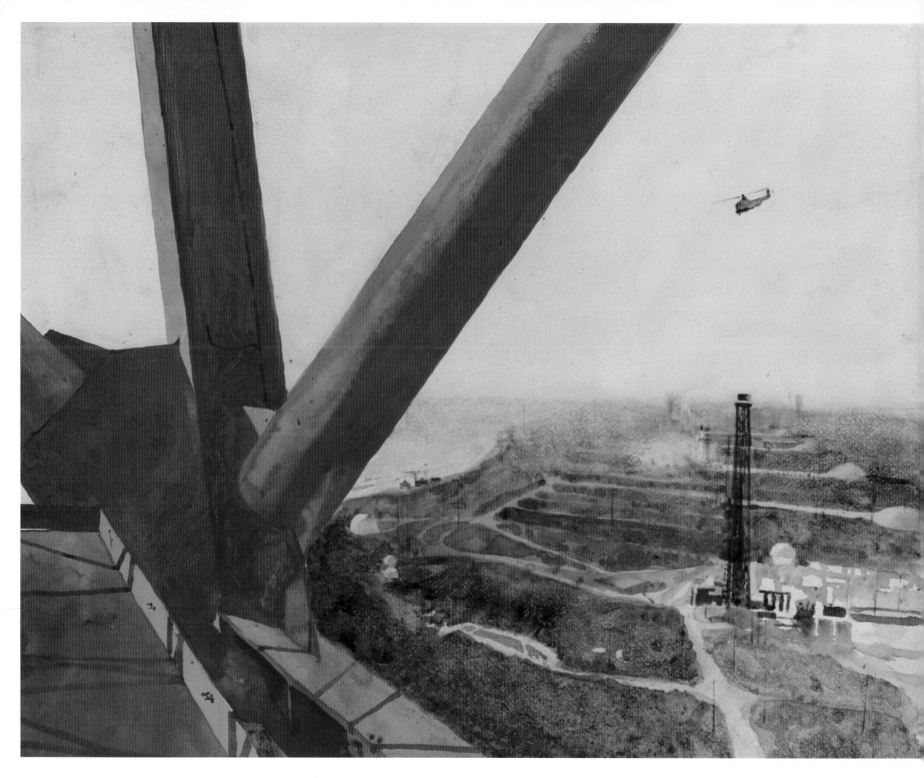

JAMES WYETH

61. *Support,* late 1960s

Air and Space

James Wyeth joined the Delaware Air National Guard in 1966. America was embroiled in the military conflict in Vietnam, which had been escalating slowly since the Kennedy administration. Kennedy and his advisers saw South Vietnam as "the Cornerstone of the Free World in Southeast Asia," the place to protect democracy against the spread of Communism in that area of the world. The conflict between North and South Vietnam was not that easily categorized, however, which baffled politicians and military men alike. What began as involvement in an "advisory capacity" was soon complicated by the organization of covert operations that took South Vietnamese raiding parties into North Vietnam. As President Johnson amplified American involvement, the public grew increasingly uneasy. James was scheduled to go to Vietnam in 1968; however, the Viet Cong then launched the deadly Tet offensive and all scheduled tours of personnel with noncombatant status were canceled. The VC forces shocked the American forces, blasting into the U.S. Embassy in Saigon, capturing the Saigon government's radio station and fighting their way into key military installations in South Vietnam. The American public, feeling manipulated and deceived, turned irreversibly against the war.

Part of James's military service involved painting a 10' x 30' mural as a backdrop for a National Guard ceremony in Wilmington, Delaware. The mural, which was never intended to be permanent, was moved twice by the National Guard and now resides in the Dining Hall of the Guard in New Castle, Delaware. Hastily painted with army issue paint on parachute nylon, the mural is rich in history and is much valued by the Guard. In an ironic choice of subject matter reflecting the sentiment of the time, James depicted the loss of innocence by Adam and Eve in the Garden of Eden. The figures, dropping the bitten apple, draw back in fear as a Delaware Air National Guard C-97 breaks the serenity of the scene. One of the clouds under the plane forms a skull, an allusion to a comic entitled "Airman Death" James drew for the Delaware Air National Guard newsletter, reportedly to promote safety procedures. In a magazine article from 1967, James said, "I'm puzzled too by the artists who spend so much energy on protest marches and speeches. I think we artists can say what we want to say through our paintings. But I can't honestly see rebellion for the sake of rebellion."[6] His rebellion is quiet, but potent.

The lows of the Vietnam conflict were contrasted with the highs of the blossoming of the Space Age in 1960s America, although fear of Russian advancement was responsible for both. The possibilities of space exploration captured the imagination of the public and millions of Americans watched raptly as the crew of Apollo 11 planted the American flag on the surface of the moon. The words of Neil Armstrong, "This is one small step for man, one giant leap for mankind," sent waves of pride through the nation.

The National Aeronautics and Space Administration (NASA), in collaboration with the National Gallery of Art, began a program in 1963 called "Eyewitness to Space." The gap between art and science was bridged as it became clear that although cameras recorded every second of every mission, the emotional impact was lost. Dozens of America's premiere artists were invited to participate in the program. They were given total access to the centers of NASA activity such as Cape Kennedy and the Houston Space Center and total freedom to create images that the experiences and places inspired. The images created were as diverse as the artists involved, which included James Wyeth, Robert Rauschenberg, Paul Calle, Lamar Dodd, and Peter Hurd.

Although occasionally James depicted the explosive and dramatic, as in *T-Minus 3 Hours 30 Minutes and Counting,* he did not always choose to portray the glamorous view of events. *Wide Load* shows the first stage of an Atlas booster on its side being transported to the launch pad like a giant awkward beast, an object without grace until it leaves the earth's atmosphere. Technological wonders and commonplace transportation are treated with equal importance in *Gemini Launch Pad,* as a red bicycle coexists with the enormous launch platform in the distance. It is this ironic juxtaposition of elements that so often characterizes the artistic eye of James Wyeth.

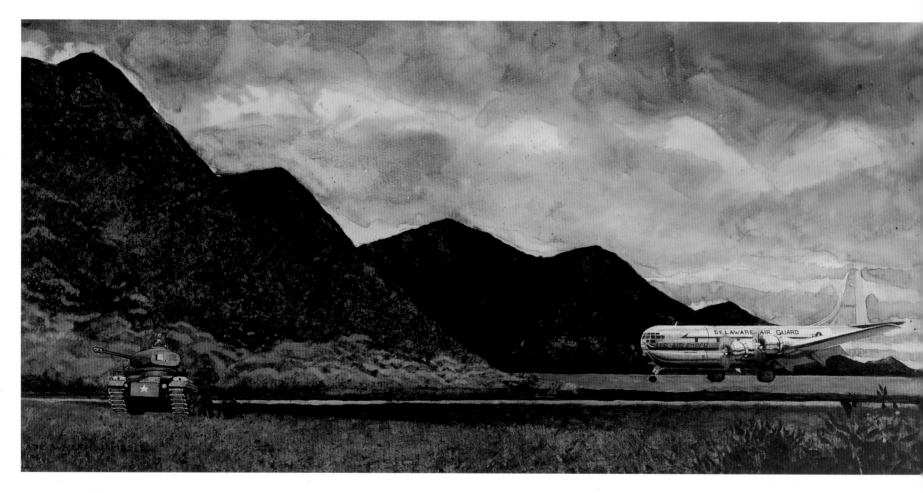

JAMES WYETH

62. *C-97 Landing in Vietnam*, c. 1969

JAMES WYETH

63. Detail—*T-Minus 3 Hours 30 Minutes and Counting*, late 1960s ▶

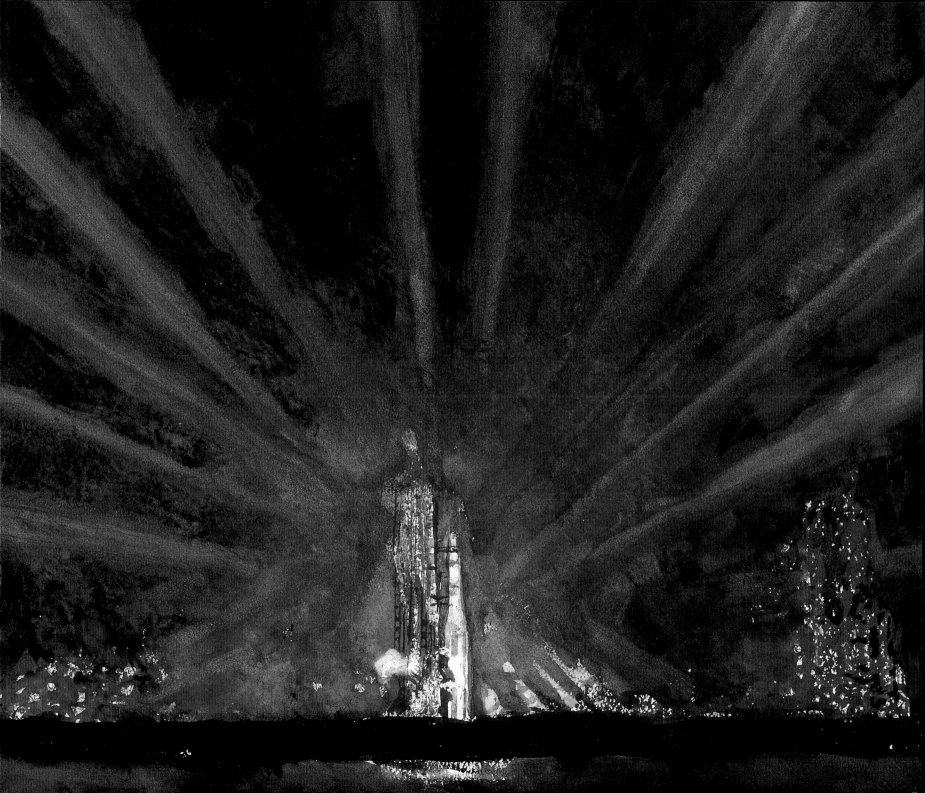

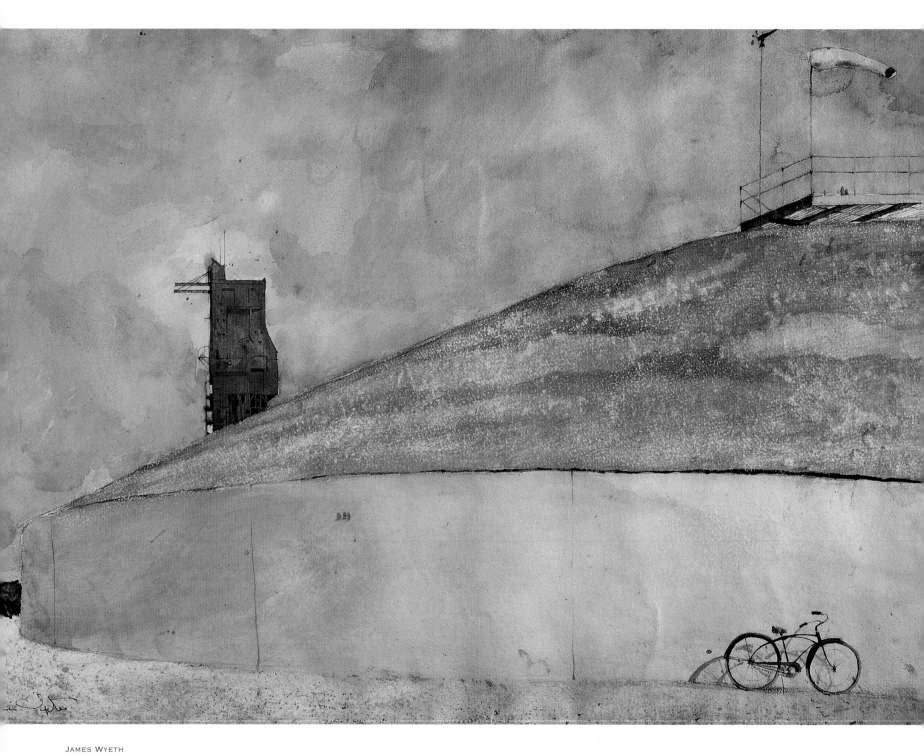

JAMES WYETH

64. *Gemini Launch Pad*, late 1960s

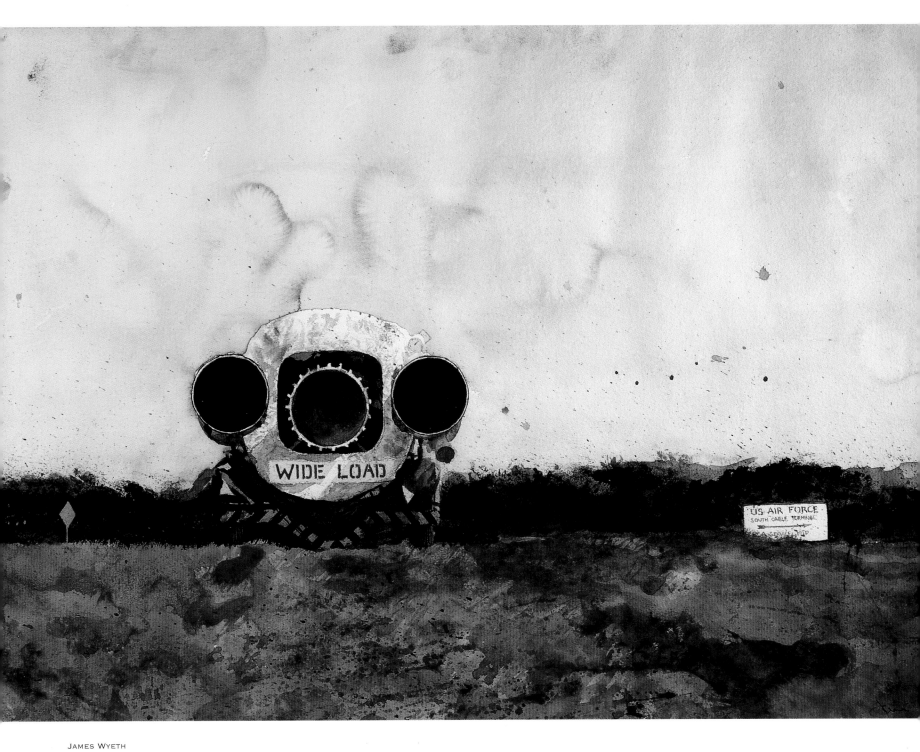

JAMES WYETH

65. *Wide Load,* late 1960s

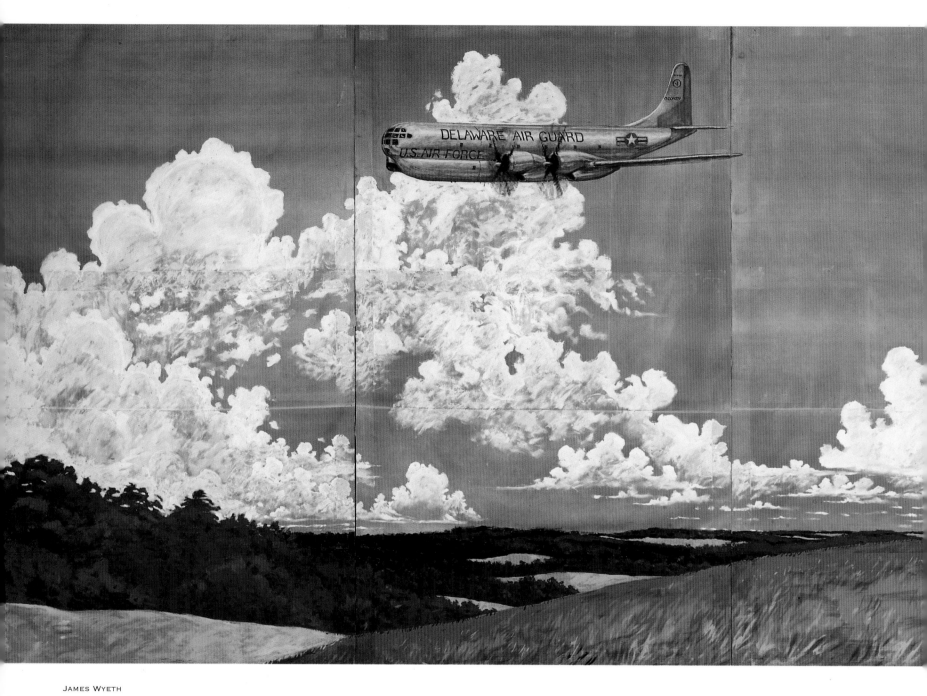

JAMES WYETH

66. *Adam and Eve and the C-97*, c. 1969

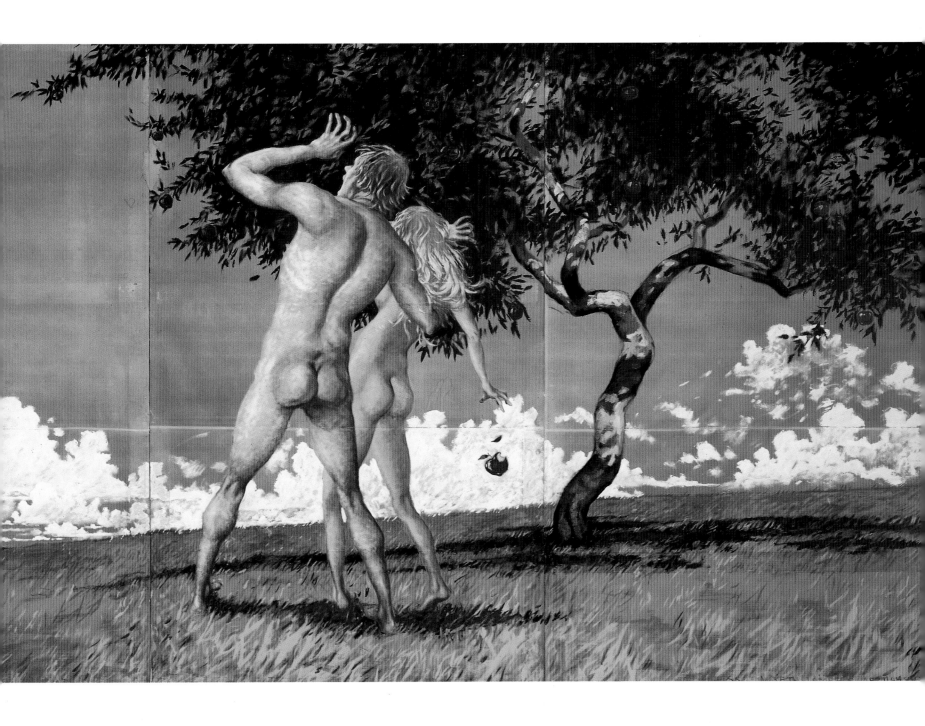

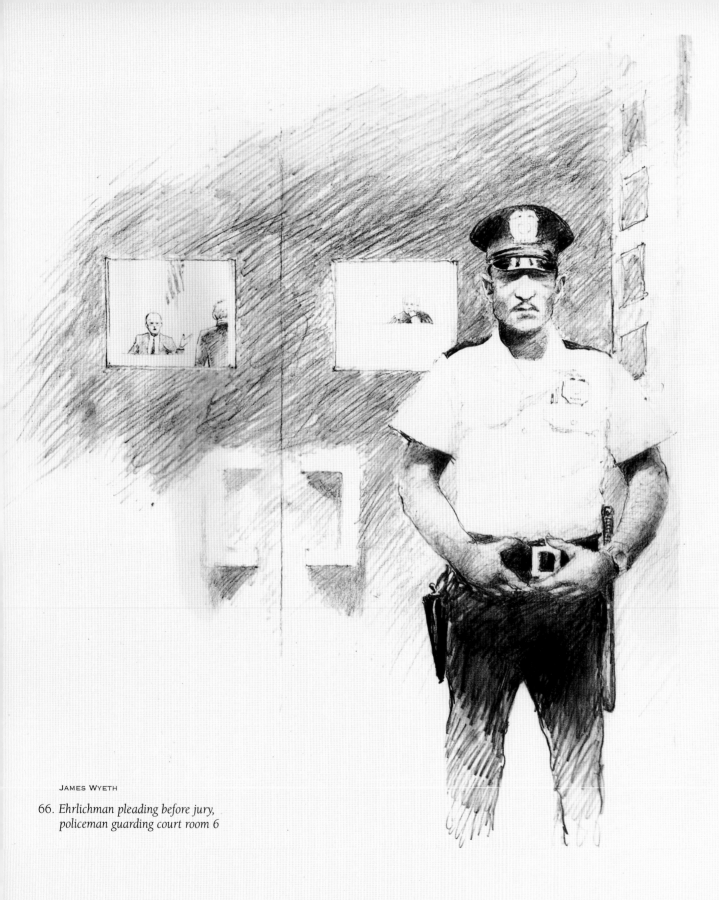

COURT
ROOM 6

JUDGE GESELL

JAMES WYETH

66. *Ehrlichman pleading before jury,*
policeman guarding court room 6

Watergate

The American public was left feeling supremely deceived, abused, and betrayed following the exposure of the corruption of the Nixon administration in the trials and congressional hearings of 1973–1974. Nixon's presidency, perhaps more than most, was characterized by a government highly polarized along party lines, with the President and his assistants ignoring the traditional rules of Washington politics, and justifying crimes as necessary for national security. These crimes, according to Nixon's former Attorney General and 1972 campaign manager, John Mitchell, included such "horrors" as forging cables to implicate Kennedy administration officials in the assassination of South Vietnamese President Ngo Dinh Diem; "a lot of miscellaneous matters" relating to Senator Edward Kennedy and Chappaquiddick; and the burglary of the offices of the psychiatrist of Daniel Ellsberg, who leaked the Pentagon Papers to the *New York Times* and the *Washington Post.* The break-in of Democratic National Committee headquarters at the Watergate office complex in June of 1972 was not the beginning of Nixon's "abuses of power," it was the beginning of the end.

G. Gordon Liddy, a White House official, and E. Howard Hunt, former CIA agent working for Liddy, recruited a group of anti-Castro Cubans to raid the Democratic National Committee headquarters to plant microphones and photograph files. The burglars, led by James McCord, director of security for the Committee to Re-Elect the President (CREEP), were caught by a night watchman, arrested, and quickly traced back to Liddy. The Watergate incident led several newspaper reporters to investigate further. A federal grand jury indicted the Cubans, McCord, Liddy, and Hunt. A plea of guilty was entered by all except Liddy and McCord, who were convicted by the jury. Judge John Sirica, who presided over the grand jury, suspected that the details of the case ran deeper than had been exposed thus far. He was proven correct when, in March 1973, McCord wrote to the judge charging that government officials had approved the burglary and conspired to cover their involvement. Nixon, in an attempt to divert suspicion from the White House, gave a televised speech in which he apologized for the actions of his "overzealous subordinates" and explained that he had failed to monitor their campaigning closely as he was absorbed in the running of the country. He announced the resignations of John Ehrlichman, chief domestic affairs adviser, and H. R. Haldeman, White House chief of staff. At the urging of others, he also appointed a special prosecutor, Harvard Law School professor Archibald Cox, to investigate the Watergate affair.

The Watergate grand jury and the Senate's special Watergate Committee, chaired by Sam Ervin of North Carolina, delved into the charges and uncovered a stunning discovery. Former White House aide Alexander Butterfield testified that presidential conversations had been routinely recorded for the last two years. When the Senate committee, as well as Special Prosecutor Cox and the Watergate grand jury, requested portions of the tapes, the President refused, arguing that their disclosure would violate executive privilege and national security. When Cox, in frustration, told a televised press conference that he would request that Judge Sirica declare the President "in violation of a court ruling" for his delay in turning over the tapes, Nixon fired Cox. The public was outraged.

Some tapes, with sizable gaps later determined to be intentional erasures, were eventually turned over. Forty-one additional people were indicted for obstruction of justice, among other crimes committed during the 1972 campaign. Edited transcripts of meetings concerning Watergate were turned over as well, and Nixon's involvement became increasingly evident. The House Judiciary Committee began work on articles of impeachment.

Nixon's fate was sealed in July and August of 1974. The Judiciary Committee heard its Democratic and Republican counsels urge impeachment and began its televised debate on July 24. That same day the Supreme Court ordered the White House to turn over sixty-four additional tapes. One of the tapes, a conversation between the President and White House Chief of Staff Haldeman on June 23, 1972, clearly indicated their attempt to mask White House involvement in the crime. In the face of certain impeachment, Nixon resigned on August 9, 1974.

Harper's magazine commissioned James Wyeth to cover the initial "Plumbers' Trial," at which no photographers were allowed. Recognizing the enormity of the scandal and the importance of his presence as an artist recording these events, James asked to continue the assignment through the congressional hearings and subsequent trials. Although the hearings were televised, James has immortalized the people and proceedings in a way that film could not. His images are powerful as historical records, as portraits of the individuals involved, and as lyrically journalistic impressions of events that changed the nation forever.

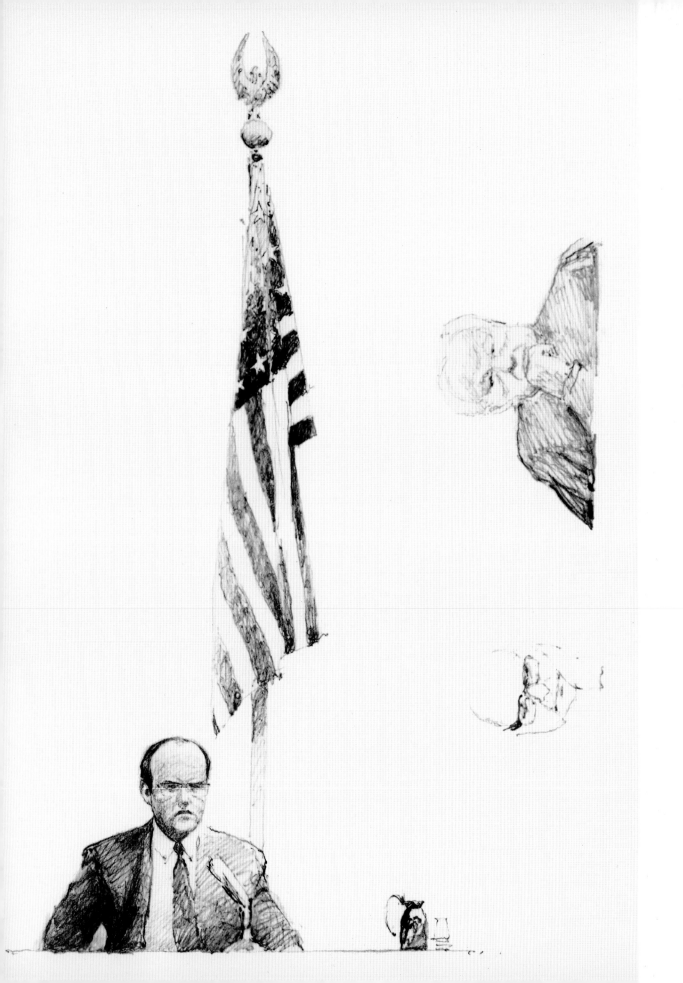

JAMES WYETH

68. *John Ehrlichman underneath flag*

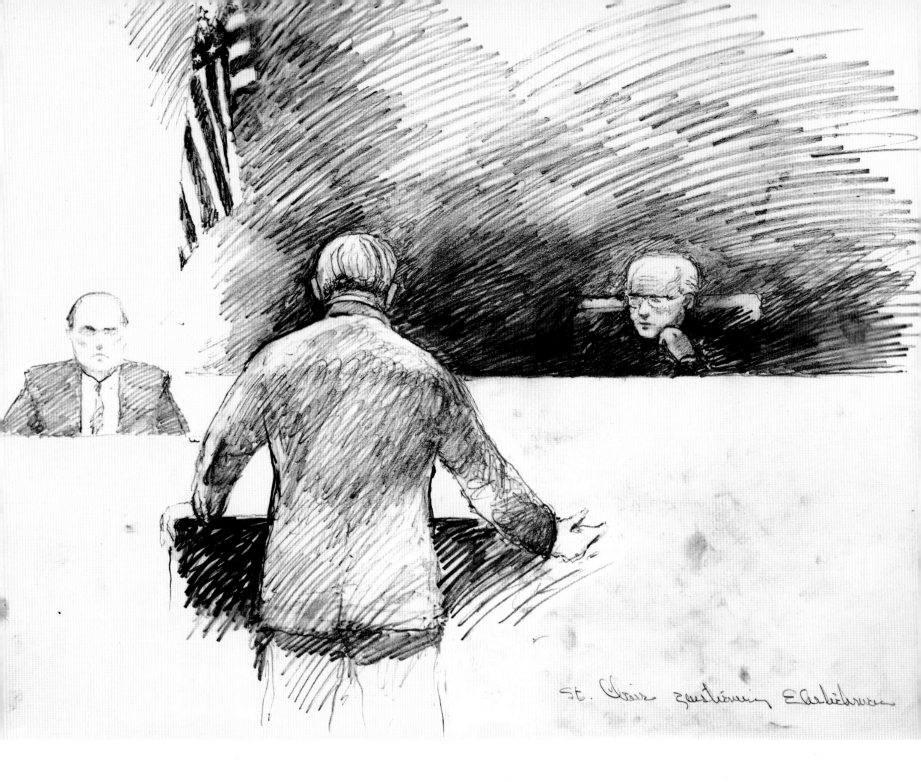

JAMES WYETH

69. *"St. Clair questioning Ehrlichman"*

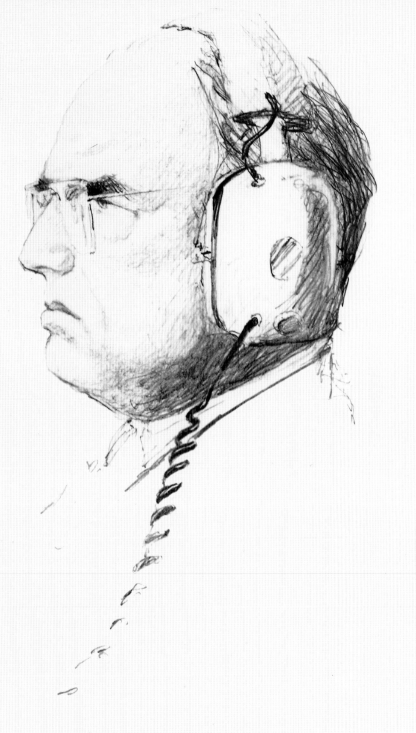

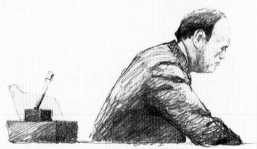

Ehrlichman starts to break down and turns away from jury

JAMES WYETH

70. *John Ehrlichman wearing headphones*

71. *"Ehrlichman starts to break down and turns away from jury"*

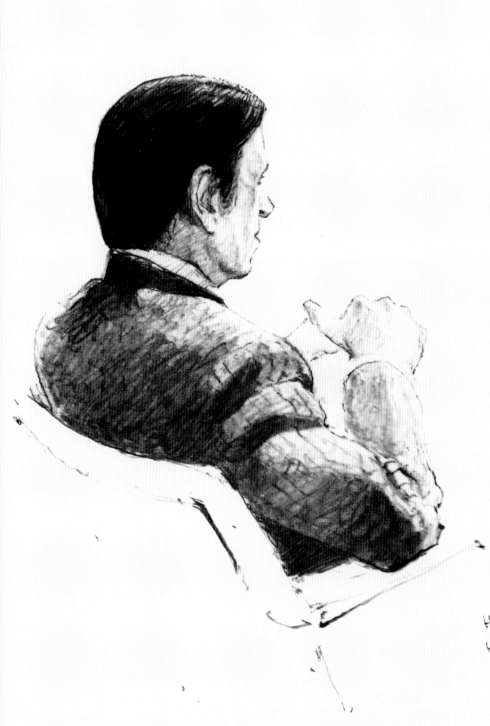

H.R.H. WATCHING VIDEOTAPE OF HIMSELF GIVING
HIS ERVIN COMMITTEE TESTIMONY

JAMES WYETH

72. *"H. R. H. watching videotape of himself giving
his Ervin committee testimony"*

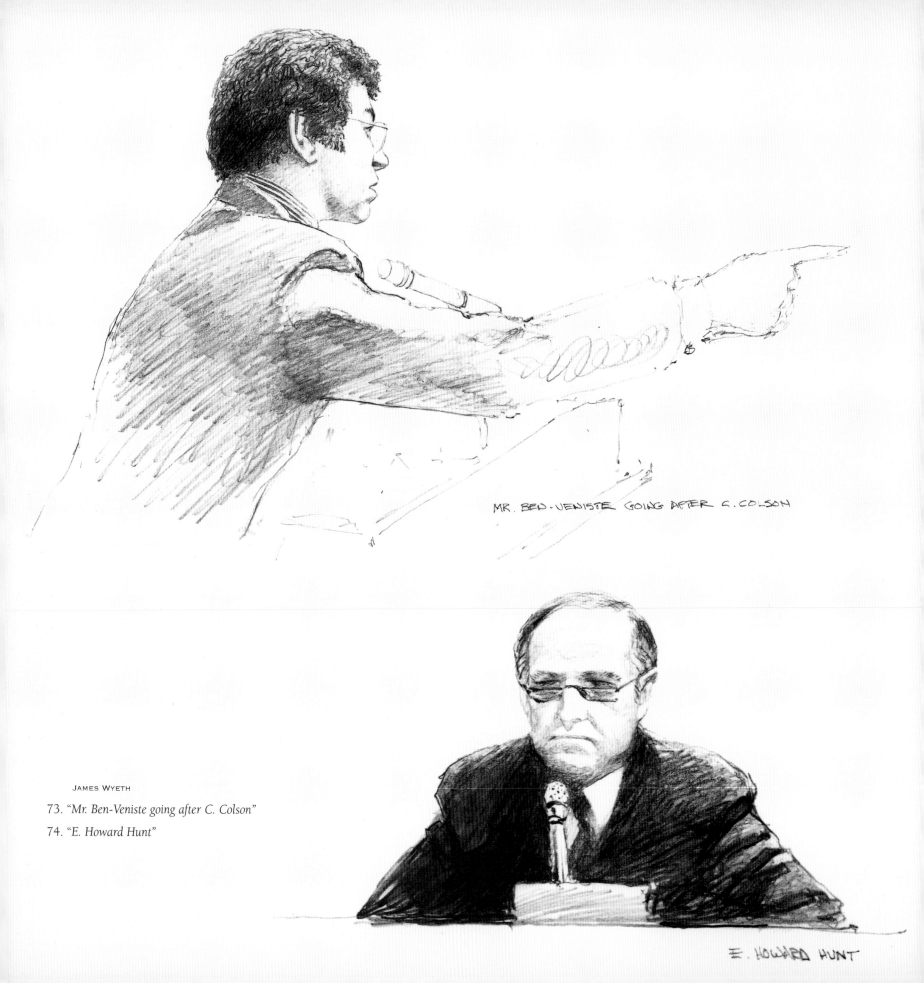

MR. BEN-VENISTE GOING AFTER C. COLSON

E. HOWARD HUNT

JAMES WYETH

73. *"Mr. Ben-Veniste going after C. Colson"*

74. *"E. Howard Hunt"*

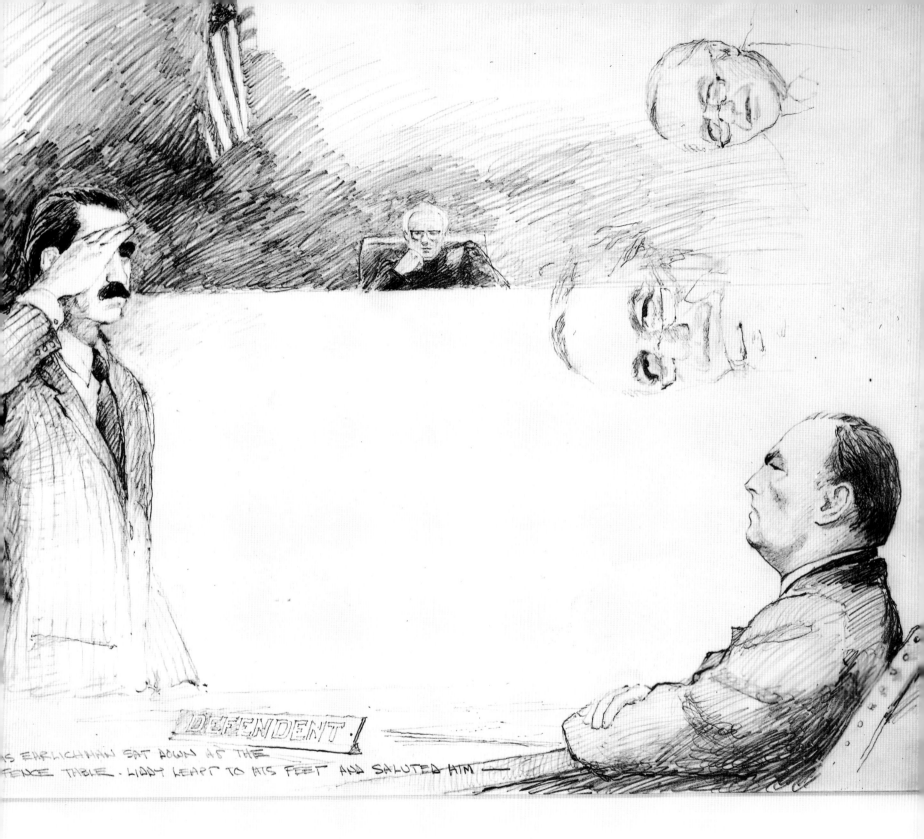

75. *"As Ehrlichman sat down at the defence table,*
 Liddy leapt to his feet and saluted him"

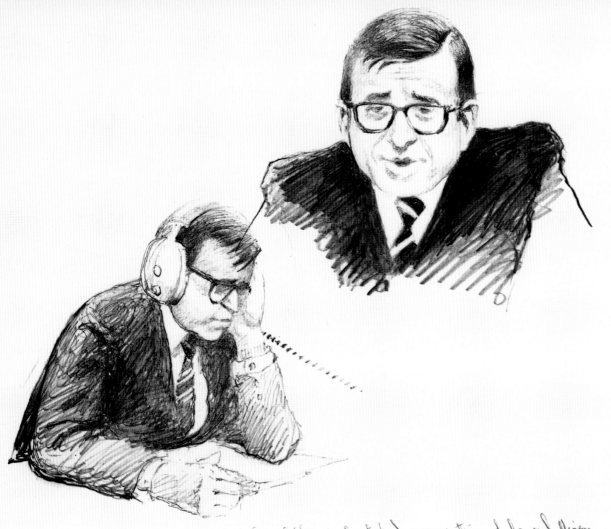

*C. Colson listening to taped conversation of he and Nixon —
and then again testifying that he didn't recall it.*

76. "*C. Colson listening to taped conversation of he and Nixon,
and then <u>again</u> testifying that he didn't recall it*"

77. "*Haldeman conferring with his attorney Wilson*"

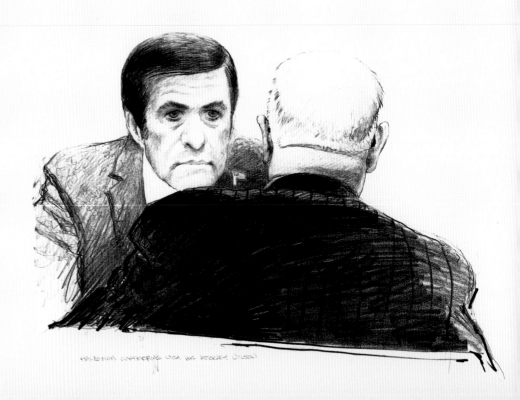

HALDEMAN CONFERRING WITH HIS ATTORNEY WILSON

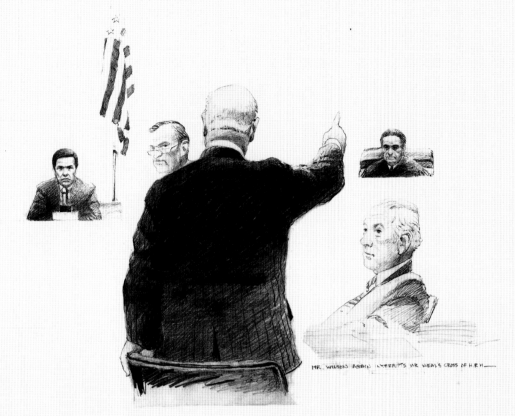

MR. WILSONS AGAIN INTERRUPTS MR NEALS CROSS OF H.R.H.

JAMES WYETH

78. *"Mr. Wilson again interrupts Mr. Neal's cross of H. R. H."*

79. *"Special prosecutor Neal tries to impeach Ehrlichman's prior testimony"*

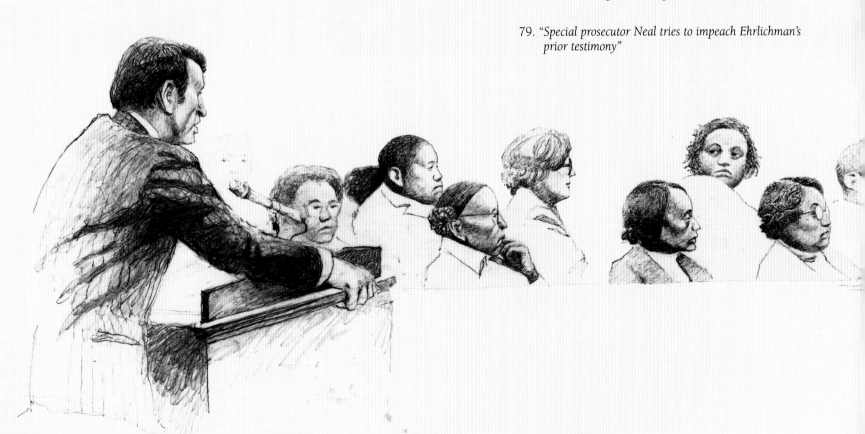

SPECIAL PROSECUTOR NEAL TRIES TO IMPEACH EHRLICHMAN'S PRIOR TESTIMONY

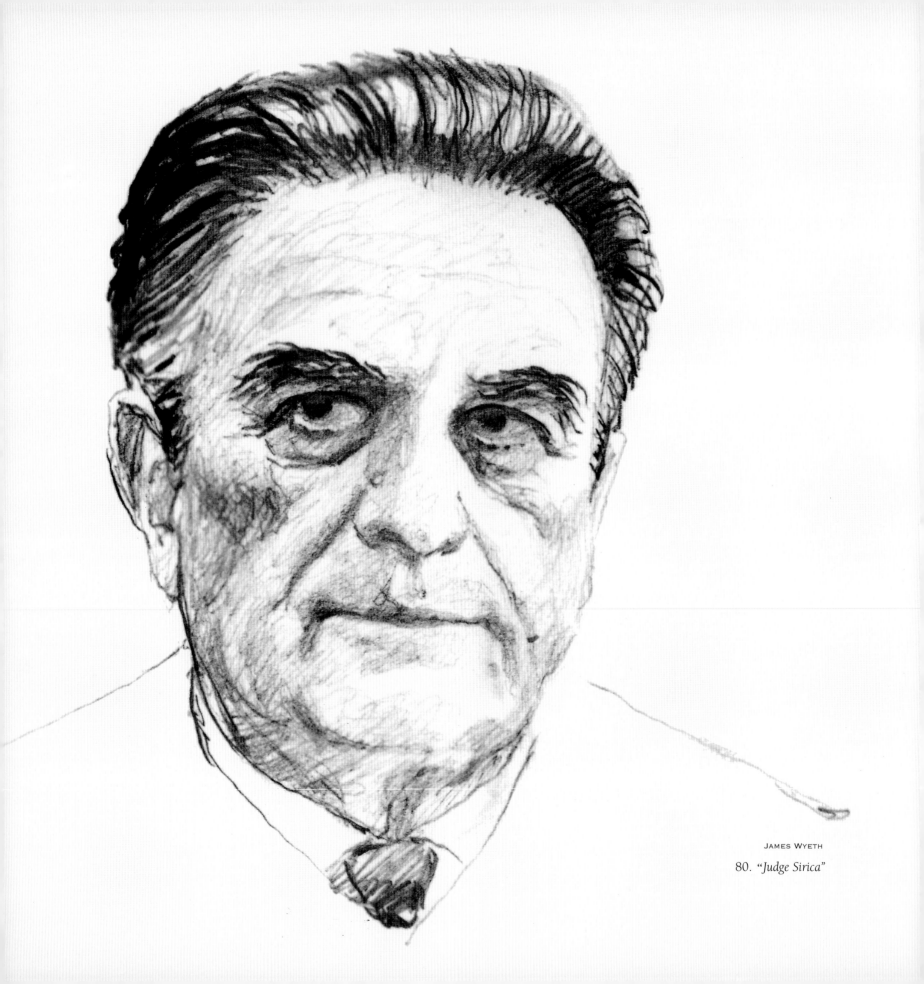

JAMES WYETH

80. *"Judge Sirica"*

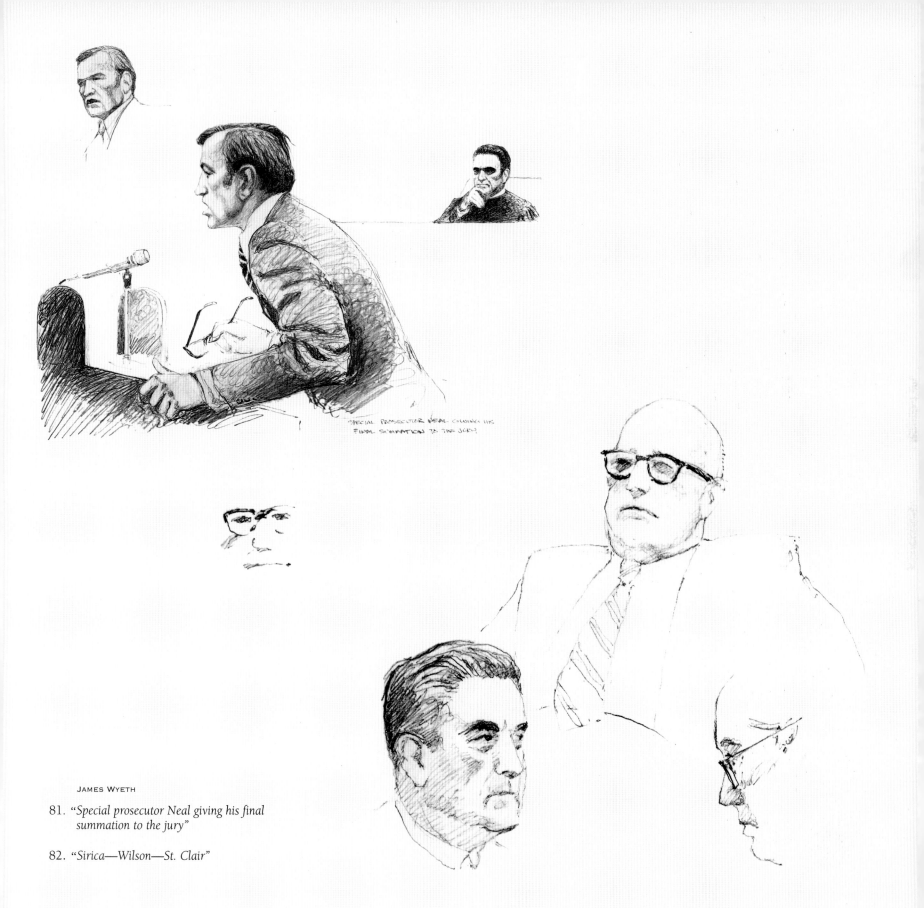

SPECIAL PROSECUTOR NEAL GIVING HIS
FINAL SUMMATION TO THE JURY

JAMES WYETH

81. *"Special prosecutor Neal giving his final
summation to the jury"*

82. *"Sirica—Wilson—St. Clair"*

Sirica — Wilson — St. Clair

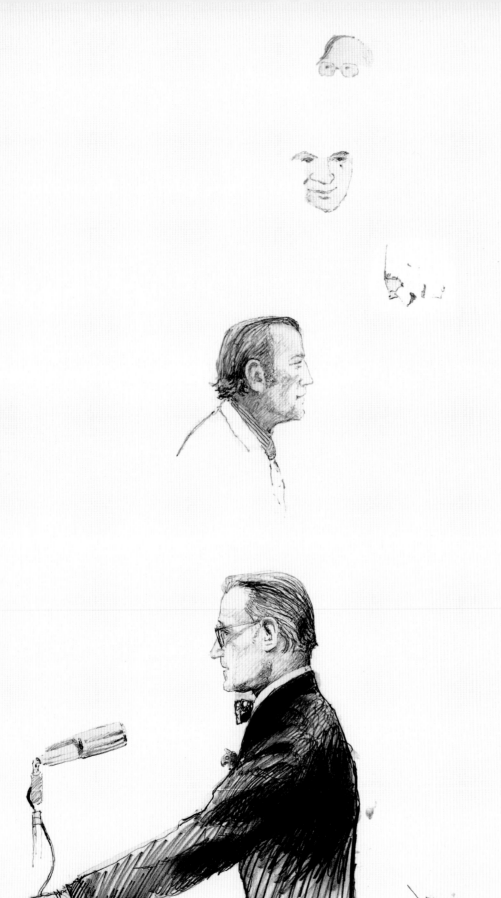

James Wyeth

83. *Albert Jenner, minority council, and Roger Mudd, of CBS-TV*

84. *"Jenner"*

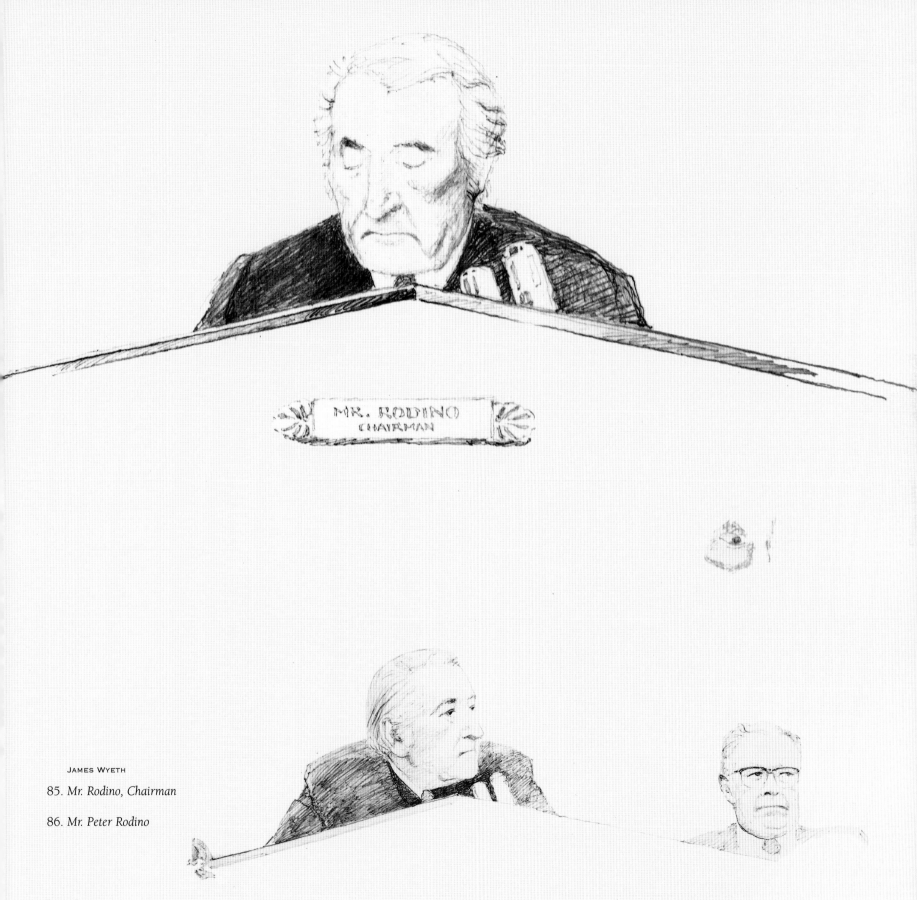

JAMES WYETH

85. *Mr. Rodino, Chairman*

86. *Mr. Peter Rodino*

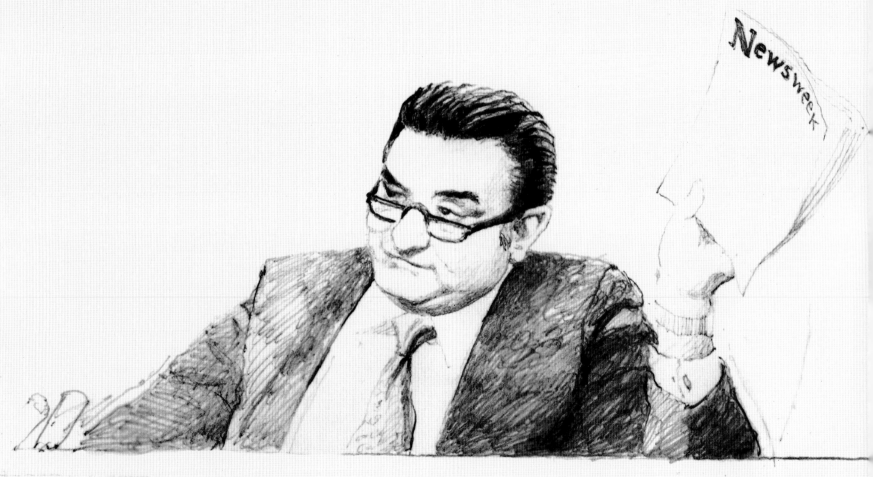

JAMES WYETH

87. *Mr. Sandman*

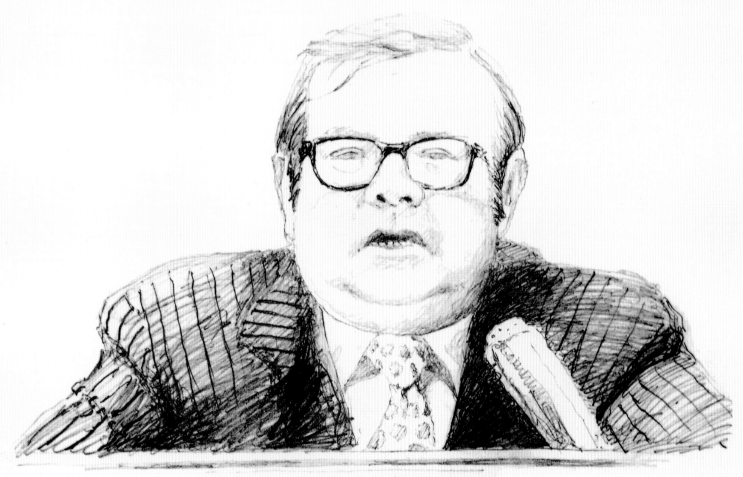

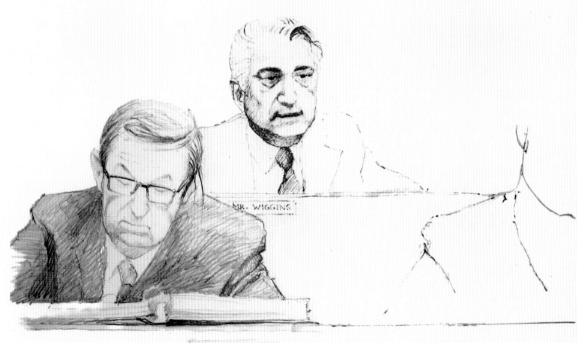

JAMES WYETH

88. *Mr. Froehlich*

89. *Mr. Caldwell Butler, Mr. Charles Wiggins*

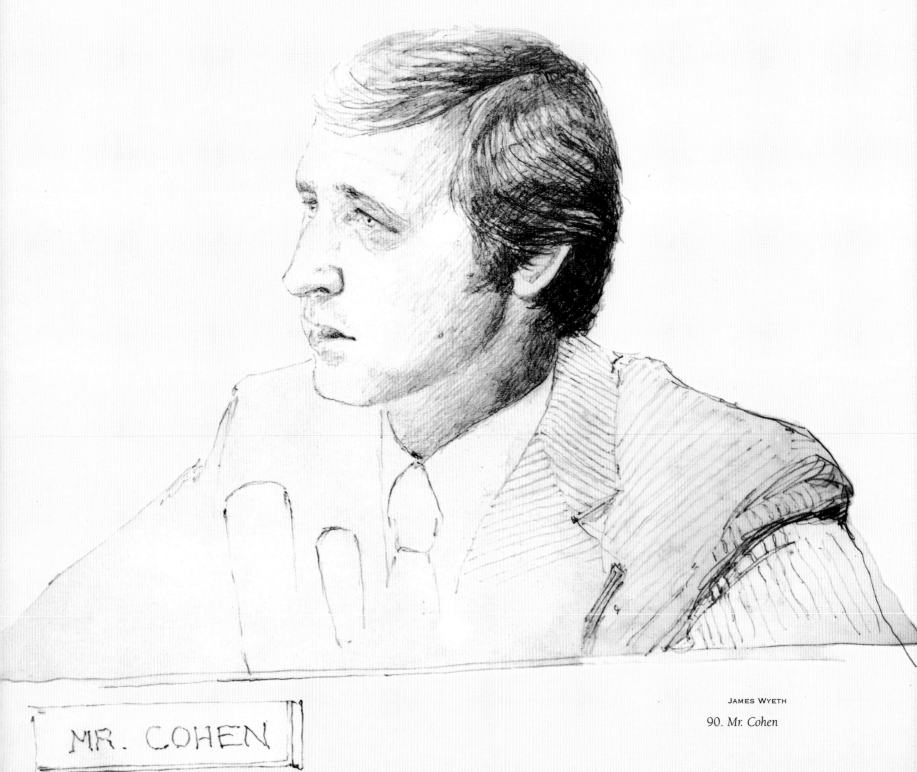

MR. COHEN

JAMES WYETH

90. *Mr. Cohen*

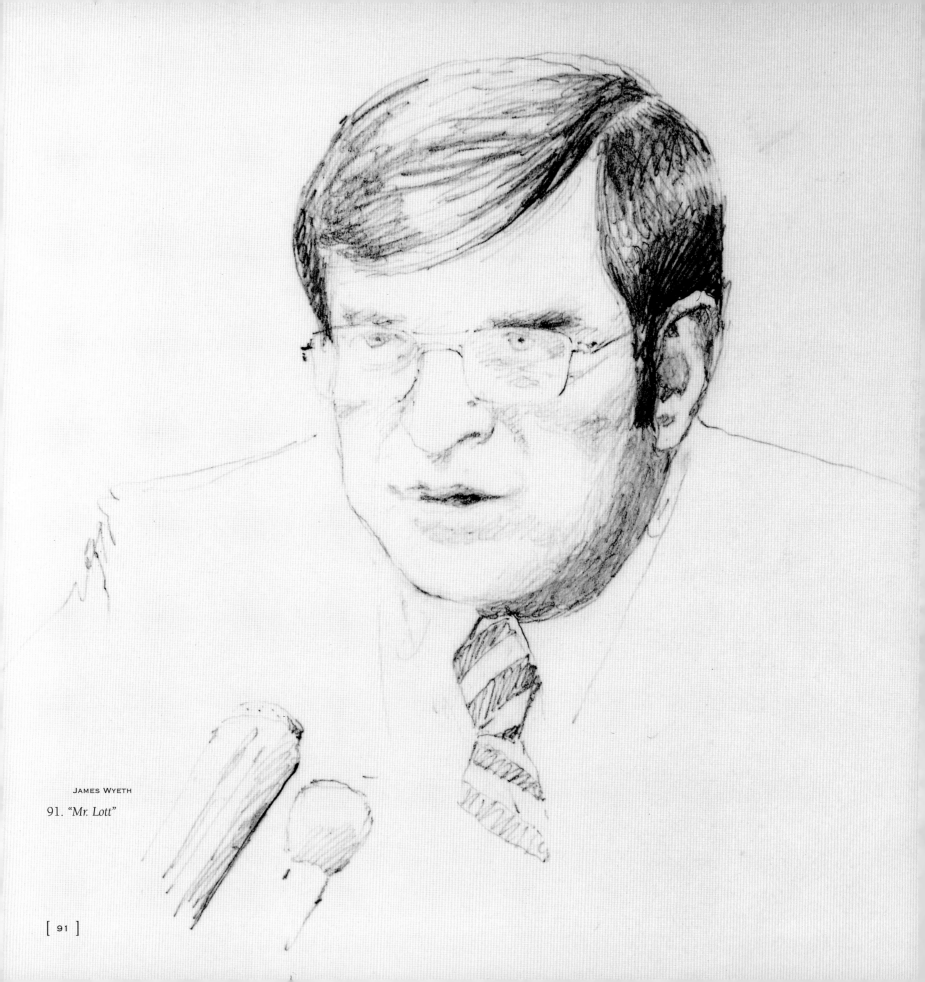

JAMES WYETH

91. *"Mr. Lott"*

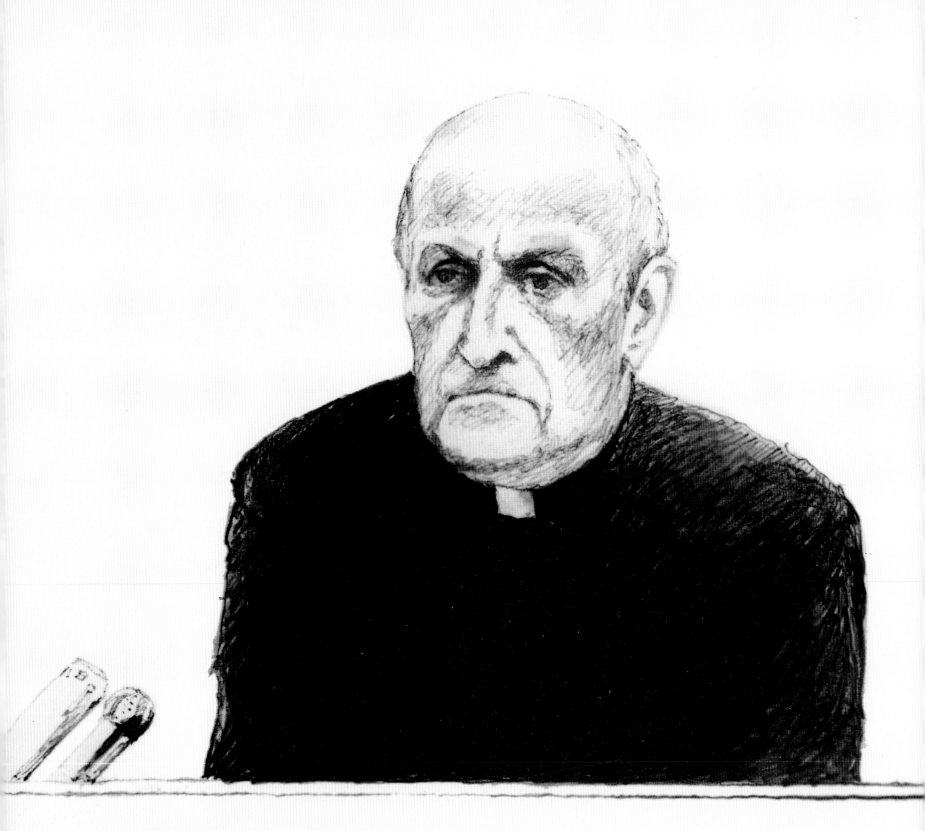

REV. DRINAN

92. *Rev. Drinan*

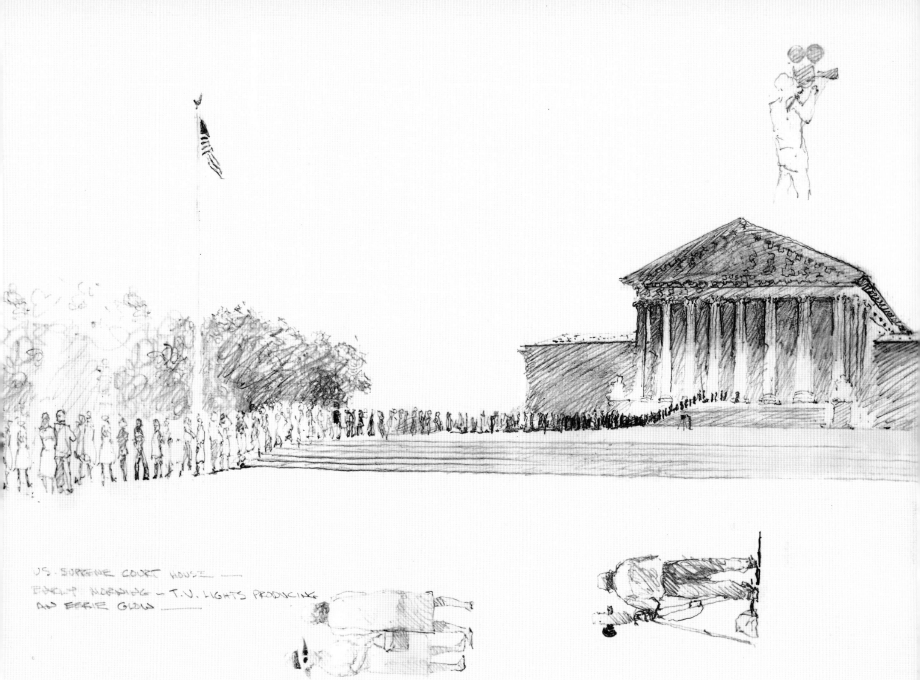

JAMES WYETH

93. *"U.S. Supreme Court House – early morning – T.V. lights producing an eerie glow"*

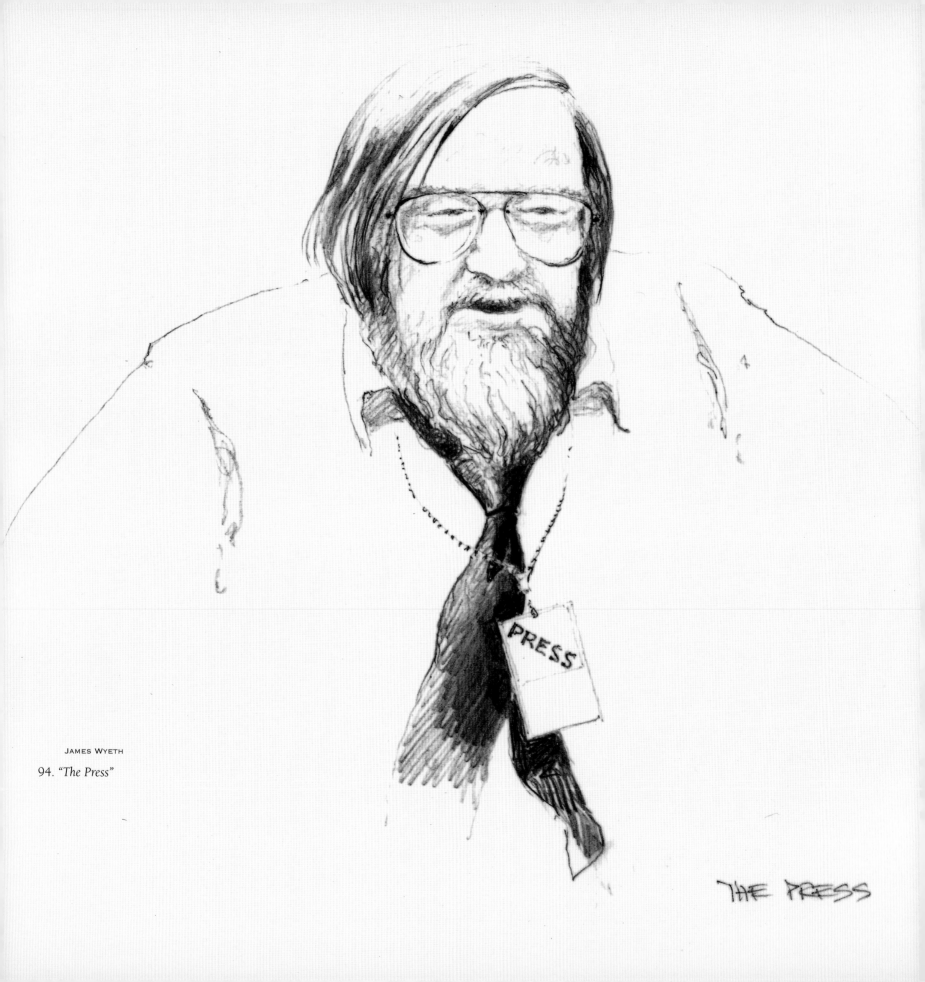

JAMES WYETH

94. *"The Press"*

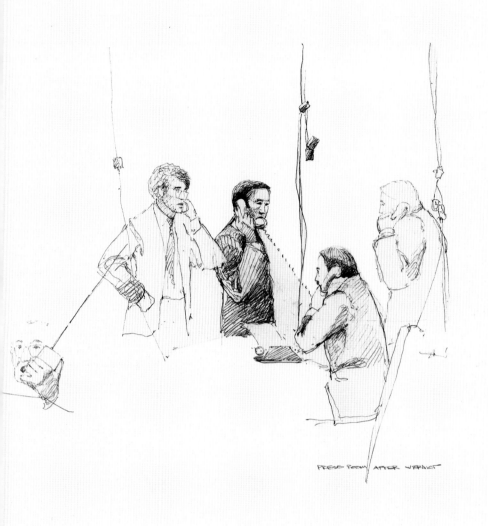

PRESS ROOM AFTER VERDICT

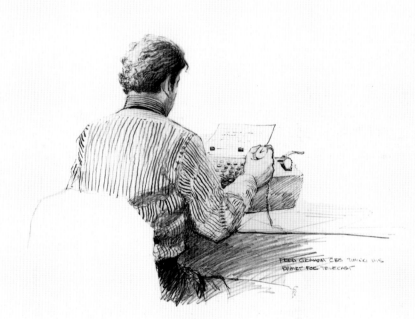

FRED GRAHAM CBS TIMING HIS REPORT FOR TELECAST

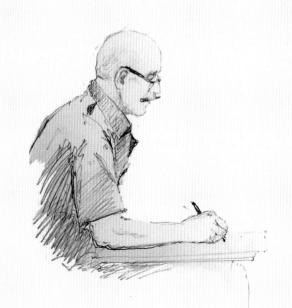

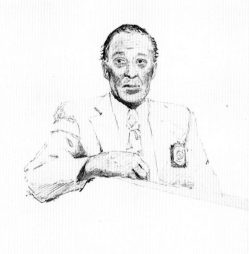

CBS ARTIST HAS COURT BAILIFF POSE FOR PORTRAIT

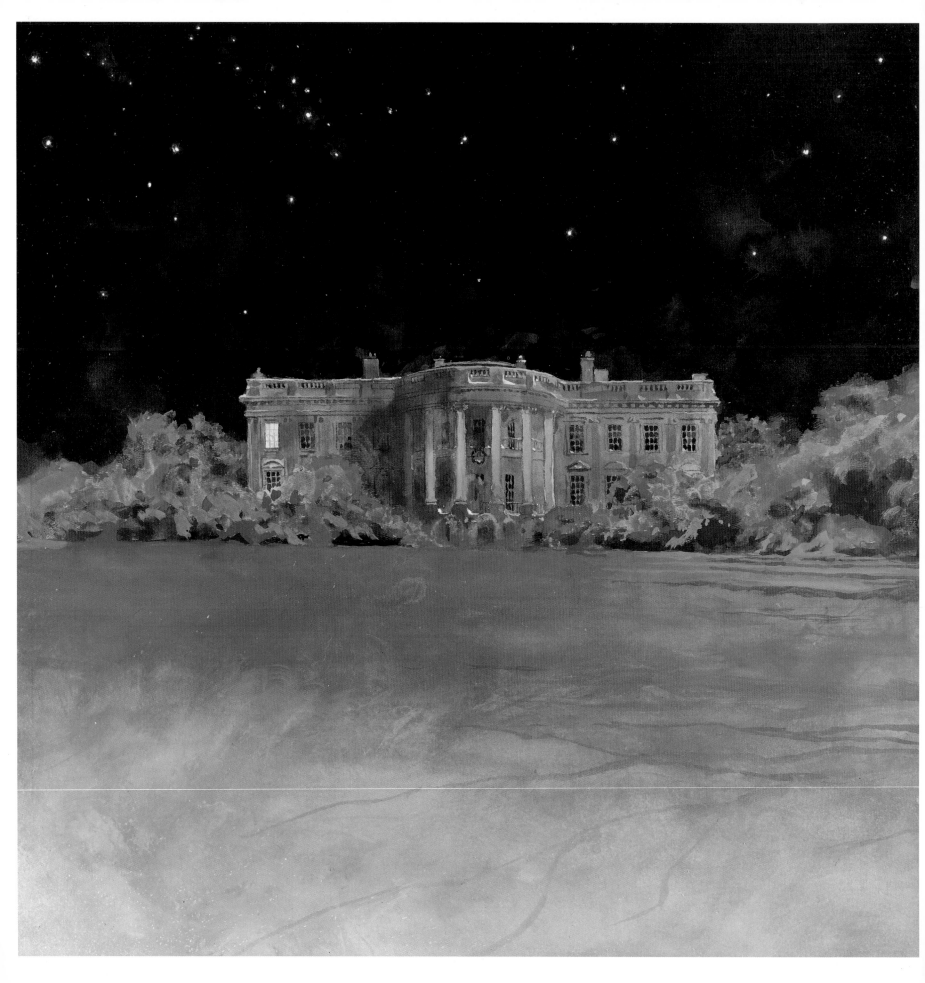

Home Fronts

Home, referring to a small shack, a palatial mansion, or even the White House, is an evocative word. James depicts a variety of "American homes" in his work, with a wide variety of inhabitants, not merely human in their aspect.

The White House is a monument to democracy, the center of our governmental universe. It seems enormous in photographs and larger still in our collective consciousness, yet, for the First Family, for at least four years, it is their home, a place where day-to-day activities continue, where living happens. James Wyeth was faced with the challenge of portraying this icon for the 1981 Christmas card for President Reagan and his family. His final painting shows that just as in most American homes on Christmas Eve, there are last-minute preparations that must be attended to late into the night, implied by the single light in the Reagans' bedroom.

In a lyrical description from a *Time* magazine article on the Reagans' Christmas, Hugh Sidey wrote about *Christmas Eve at the White House,* "The giant flakes covered the fountain on the South Lawn and blotted out the driveways. Cars disappeared. Falling snow hushed the city and drew a purple night around it. Wyeth stilled the melancholy world with his lovely strokes and brought the stars out one by one on Christmas Eve. He lighted the window of the Reagans' bedroom with an artist's alchemy of oil and watercolor, a small golden rectangle of warmth and hope."[7]

In a more humble setting, *Islanders* shows two men sitting on the porch of a small house, both of whom are dwarfed by a large American flag hanging awkwardly from the roof. The focus is not on the house, as in the White House paintings, but in the juxtaposition of the figures and the flag. It is uncertain whether the flag is engulfing or protecting the two men. James once again creates an unusual interplay between the serious symbolism inherent in the hanging of the flag and the irreverent appearance of the two men on the porch in their costume-like attire. Indeed, this could be a scene from a peculiar play, the plot of which is known only by the artist.

The American flag appears again in a more traditional role in James's second painting for the White House Christmas card from 1984, also for the Reagans. He chose a more intimate view of the house, a view of the North Portico with the chains of the lantern draped in garland, Christmas trees flanking the front door, and the flag waving proudly over it all. *Christmas Morning at the White House* depicts the home with a small squirrel as a visitor, its tracks the only blemish on the blanket of fresh snow.

When commissioned to paint *Vice President's House,* James chose to represent the grand Victorian house as a backdrop for Vice President Gore's black Labrador retriever, Shiloh, capering playfully in the snow. The well-lit home appears as a beacon in the cold winter night.

James has been asked to paint the official portrait of the White House for its bicentennial anniversary, to be unveiled in the fall of 2000. He has spent many hours on the White House lawn, studying the house from every angle to capture just the right image. He speaks of his impressions of the house: "It's just so amazing that this is the home of the leader of the free world, yet it is really not a large structure. Visitors come expecting to see something on the scale of Versailles, and here is this comparatively small house on the hill, but it is the center of power for this country."

98. *Christmas Eve at the White House,* 1981

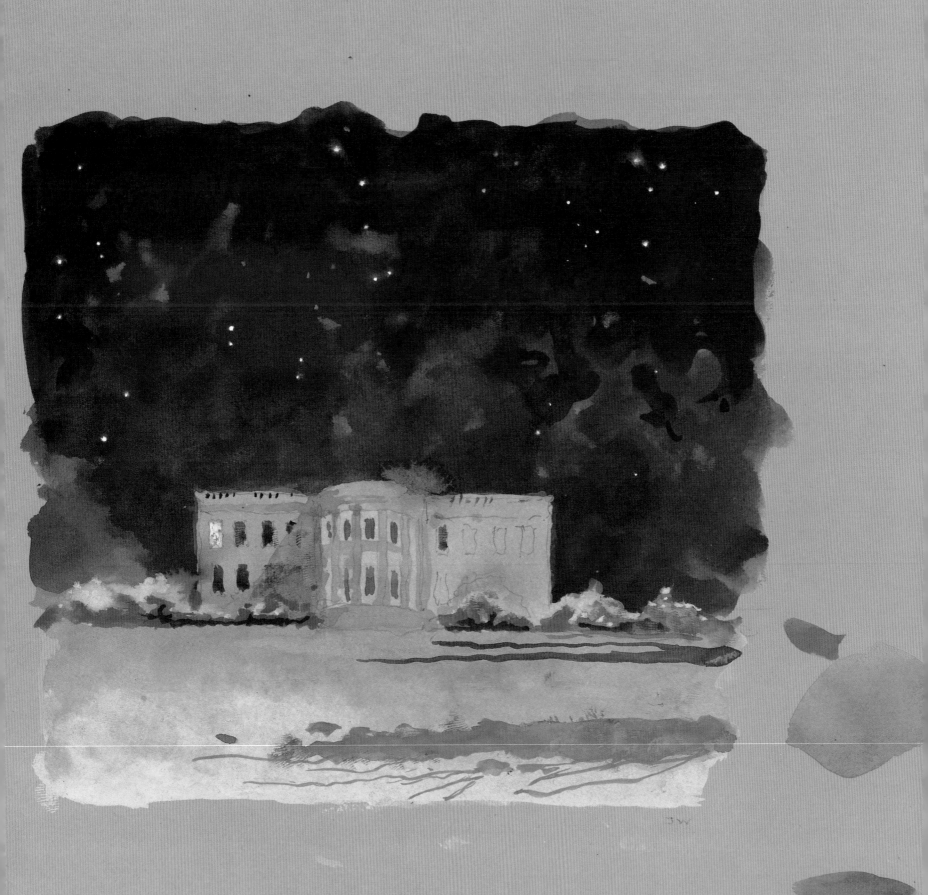

99. *Study for Christmas Eve at the White House,* 1981

100. *Vice President's House,* 1996

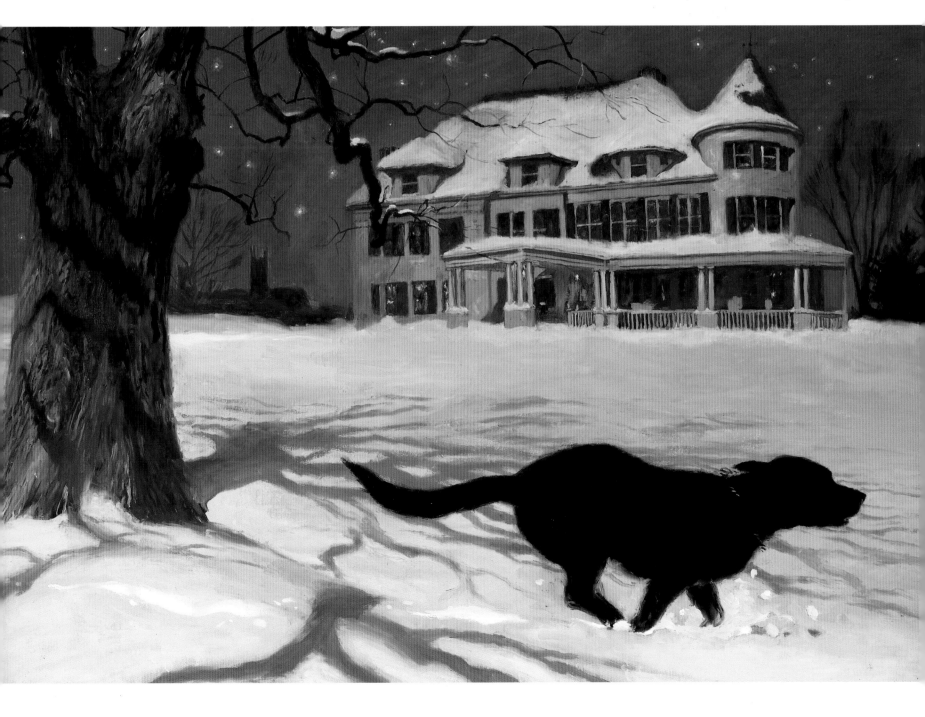

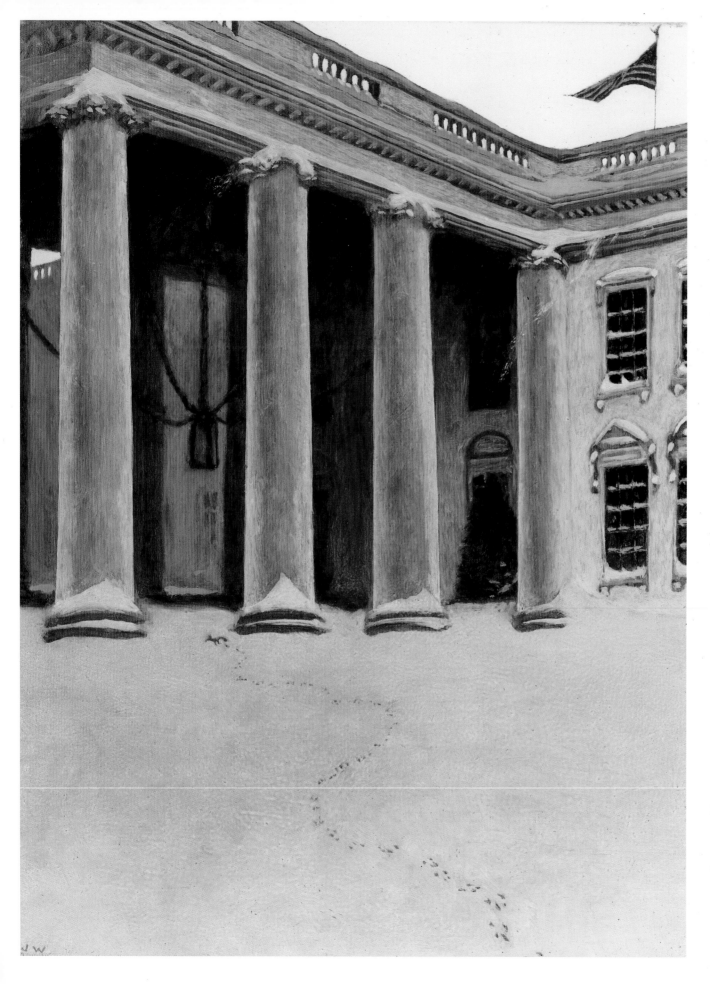

JAMES WYETH

101. *Christmas Morning
at the White House,* 1984

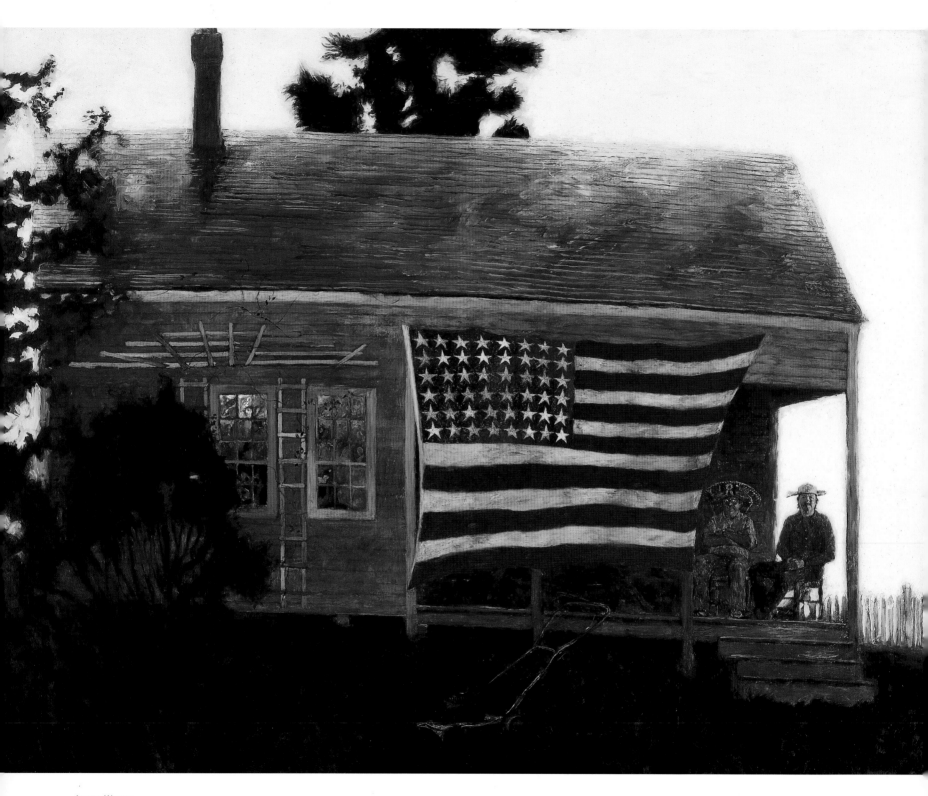

JAMES WYETH

103. *Islanders*, 1990

Lenders to the Exhibition

Bank One Art Collection

Brandywine River Museum

Mrs. Louis Cabot

Mrs. Charles S. Crompton, Jr.

Delaware Air National Guard, New Castle, Delaware

Mr. and Mrs. Frank E. Fowler

Mort and Deborah Künstler

MBNA America

Millport Conservancy

National Air and Space Museum, Smithsonian Institution, Washington, D.C.

School Department of the Town of Needham, Massachusetts

Suzanne and Joel Sugg

Mr. Daniel K. Thorne

Virginia Military Institute Museum

Mr. Alan C. Wasserman

Mr. and Mrs. James Wyeth

Mrs. Jane Wyeth

List of Plates

N. C. Wyeth

Frontispiece
Buy War Bonds, 1942
Illustration for poster by the U.S. Government Printing Office, 1942.
Reproduction, 39¾″ x 29¾″
From the Collection of Alan C. Wasserman

Opposite Essay by Tom Brokaw
The War Letter, 1941
Tempera on Panel, 37″ x 46″
Collection of the Brandywine River Museum, Gift of Carolyn Wyeth in Memory of Deo du Pont Weymouth and Tyler Weymouth

1. *Washington at Yorktown,* 1940
Illustration for "America in the Making," a calendar for John Morrell and Company, Ottumwa, IA, 1940.
Oil with some areas of tempera on panel, 27″ x 25″
From the Collection of the University Museums, Iowa State University

2. *Building the First White House Washington, D.C. 1798,* c. 1930
Illustration for "Pennsylvania Railroad Patriotic Posters No. 4," Pennsylvania Railroad, Philadelphia, PA, 1930. Reproduced for presidential Christmas card. Hallmark Cards, 1971.
Courtesy of the Hallmark Archives, Hallmark Cards, Inc.
Original artwork whereabouts unknown

3. *Captain John Paul Jones,* 1940
Illustration for "America in the Making," a calendar for John Morrell and Company, Ottumwa, IA, 1940.
Oil with some areas of tempera on panel, 27″ x 25″
From the Collection of the University Museums, Iowa State University

4. *On the Sea Wall With John Paul Jones* "For a long moment John Paul Jones gazed out over the crowded ship down the long narrow harbor out to the open water. He whistled dolefully between his teeth," 1928
Illustration for *Drums* by James Boyd. New York: Charles Scribner's Sons, 1928.
Oil on canvas, 40″ x 32″
Collection of MBNA America

5. *Thomas Jefferson,* 1940
Illustration for "America in the Making," a calendar for John Morrell and Company, Ottumwa, IA, 1940.
Oil with some areas of tempera on panel, 27″ x 25″
From the Collection of the University Museums, Iowa State University

6. *Abraham Lincoln,* 1940
Illustration for "America in the Making," a calendar for John Morrell and Company, Ottumwa, IA, 1940.
Oil with some areas of tempera on panel, 27″ x 25″
From the Collection of the University Museums, Iowa State University

7. *Study for Lincoln's Second Inaugural Address,* c. 1923
Charcoal on paper, 15½″ x 13¼″
From the Collection of Betye and Alan C. Wasserman

8. *He Saved the Union. Lincoln delivers his second inaugural address as President of the United States, March 4, 1865,* c. 1923
Illustration for *A History of Our Country* by William J. Long. Boston: Ginn and Company, 1923.
Oil on canvas, 34″ x 24″
Collection of MBNA America

9. *The Courier,* 1912
Illustration for "Sally Castleton" by Crittenden Marriott. *Everybody's Magazine,* June 1912.
Oil on canvas, 33¼″ x 47¼″
Collection of Frank E. Fowler

10. *The Vedette,* 1910
Illustration for *The Long Roll* by Mary Johnston. Boston: Houghton Mifflin Company, 1911.
Oil on canvas, 47″ x 38″
Private Collection

11. *Stonewall Jackson,* 1910
Illustration for *The Long Roll* by Mary Johnston. Boston: Houghton Mifflin Company, 1911.
Oil on canvas, 47¼″ x 38¼″
Collection of the Virginia Military Institute Museum

12. *The Battle,* 1910
Illustration for *The Long Roll* by Mary Johnston. Boston: Houghton Mifflin Company, 1911.
Oil on canvas, 46″ x 37″
Private Collection

13. *The Road to Vidalia,* 1912
Illustration for *Cease Firing* by Mary Johnston. Boston: Houghton Mifflin Company, 1912.
Oil on canvas, 47″ x 37″
Collection of Mr. and Mrs. James Wyeth

14. *The Bloody Angle,* 1912
Illustration for *Cease Firing* by Mary Johnston. Boston: Houghton Mifflin Company, 1912.
Oil on canvas, 45″ x 30″
Collection of Mrs. Charles S. Crompton, Jr.

15. *The Old Continentals,* 1922

Illustration for *Poems of American Patriotism* by Brander Matthews. New York: Charles Scribner's Sons, 1922.

Oil on canvas, 40″ x 28″

From The Hill School Collection, Pottstown, PA

16. *Barbara Frietchie,* 1922

Illustration for *Poems of American Patriotism* by Brander Matthews. New York: Charles Scribner's Sons, 1922.

Oil on canvas, 40″ x 30″

From The Hill School Collection, Pottstown, PA

17. *Paul Revere's Ride,* 1922

Illustration for *Poems of American Patriotism* by Brander Matthews. New York: Charles Scribner's Sons, 1922.

Oil on canvas, 40″ x 30″

From The Hill School Collection, Pottstown, PA

18. *Warren's Address to His Troops at Bunker Hill,* 1922

Illustration for *Poems of American Patriotism* by Brander Matthews. New York: Charles Scribner's Sons, 1922.

Oil on canvas, 40″ x 30″

From The Hill School Collection, Pottstown, PA

19. *Nathan Hale,* 1922

Illustration for *Poems of American Patriotism* by Brander Matthews. New York: Charles Scribner's Sons, 1922.

Oil on canvas, 40″ x 30″

From The Hill School Collection, Pottstown, PA

20. *Washington Reviewing His Troops,* 1922

Illustration for *Poems of American Patriotism* by Brander Matthews. New York: Charles Scribner's Sons, 1922.

Oil on canvas, 40″ x 30″

From The Hill School Collection, Pottstown, PA

21. *George Washington,* 1922

Illustration for *Poems of American Patriotism* by Brander Matthews. New York: Charles Scribner's Sons, 1922.

Oil on canvas, 40″ x 30″

From The Hill School Collection, Pottstown, PA

22. *John Burns of Gettysburg,* 1922

Illustration for *Poems of American Patriotism* by Brander Matthews. New York: Charles Scribner's Sons, 1922.

Oil on canvas, 40″ x 30″

From The Hill School Collection, Pottstown, PA

23. *The Regular Army Man,* 1922

Illustration for *Poems of American Patriotism* by Brander Matthews. New York: Charles Scribner's Sons, 1922.

Oil on canvas, 40″ x 30″

From The Hill School Collection, Pottstown, PA

24. *Sherman,* 1922

Illustration for *Poems of American Patriotism* by Brander Matthews. New York: Charles Scribner's Sons, 1922.

Oil on canvas, 40″ x 30″

From The Hill School Collection, Pottstown, PA

25. *Grant,* 1922

Illustration for *Poems of American Patriotism* by Brander Matthews. New York: Charles Scribner's Sons, 1922.

Oil on canvas, 40″ x 30″

From The Hill School Collection, Pottstown, PA

26. *O Captain! My Captain!,* 1922

Illustration for *Poems of American Patriotism* by Brander Matthews. New York: Charles Scribner's Sons, 1922.

Oil on canvas, 40″ x 30″

From The Hill School Collection, Pottstown, PA

27. *Our Mother,* 1922

Illustration for *Poems of American Patriotism* by Brander Matthews. New York: Charles Scribner's Sons, 1922.

Oil on canvas, 40″ x 30″

From The Hill School Collection, Pottstown, PA

28. *Poems of American Patriotism, Endpaper Illustration,* 1922

Illustration for *Poems of American Patriotism* by Brander Matthews. New York: Charles Scribner's Sons, 1922.

Oil on canvas, 40″ x 47″

From The Hill School Collection, Pottstown, PA

29. *The Unknown Soldier,* 1922

Illustration for *Poems of American Patriotism* by Brander Matthews. New York: Charles Scribner's Sons, 1922.

Oil on canvas, 40″ x 30″

From The Hill School Collection, Pottstown, PA

30. *Poems of American Patriotism, Cover Illustration,* 1922

Illustration for *Poems of American Patriotism* by Brander Matthews. New York: Charles Scribner's Sons, 1922.

Oil on canvas, 40″ x 28″

From The Hill School Collection, Pottstown, PA

31. *WWI Poster,* 1918

Illustration for American Red Cross poster, 1918.

Oil on canvas, 39 ½″ x 29 ½″

Collection of Suzanne and Joel Sugg

32. *Kamerad!,* 1919
Illustration for "Series of Great War Paintings." *Pictorial Review,* March 1919.
Oil on canvas, 39 ½" x 35 ½"
Collection of Mort and Deborah Künstler

33. *The Abdication of Attila,* 1917
Illustration refused by *Life Magazine,* 1917.
Oil on canvas, 40" x 36"
Collection of the Brandywine River Museum, Bequest of Carolyn Wyeth

34. *Twentieth Century and the First, The Dramatic Contrast of an English Tank in the Streets of Jerusalem,* 1918
Illustration for "The New Crusaders Enter Jerusalem." *The Red Cross Magazine,* June 1918.
Oil on canvas, 38 ⁵⁄₁₆" x 31 ¼"
Collection of the Brandywine River Museum, Bequest of Carolyn Wyeth

35. *The Sign in the Heavens Which the Judean Shepherds Watching Their Flocks See This Year,* 1918
Illustration for "The New Crusaders Enter Jerusalem." *The Red Cross Magazine,* June 1918.
Oil on canvas, 39 ½" x 31"
Collection of the Millport Conservancy

36. *The Victorious Allies,* c. 1918
Cover illustration. *The Red Cross Magazine,* March 1919.
Oil on canvas, 46 ⅛" x 35 ¼"
Collection of the Delaware Art Museum

37. *America's Greatest Wealth Is in Her Healthy Children,* c. 1925
Illustration for *The Practical Health Series* by Mace J. Andress and W. A. Evans. Boston: Ginn and Company, 1925.
Oil on canvas, 34" x 24"
Collection of the School Department of the Town of Needham, Massachusetts

38. *It was after this attack that the High Command published to the German army: "The moral effect of our own gunfire cannot seriously impede the advance of the American Infantry,"* 1930
Illustration for "Belleau Wood, June 1918." *Redbook Magazine,* July 1930.
Oil on canvas, 36 ¼" x 56 ¼"
Collection of the Brandywine River Museum, Bequest of Carolyn Wyeth

39. *Amateurs at War: The American Soldier in Action,* 1943
Charcoal on paper, 44 ½" x 31 ¼"
Collection of the Brandywine River Museum, Gift of Mr. and Mrs. Andrew Wyeth

40. *Marines Landing on the Beach,* 1944
Cover illustration for "Picture Parade." *The Philadelphia Inquirer,* June 11, 1944. Illustration for "Display Poster" by E. R. Squibb & Sons, 1944.
Oil on panel, 42" x 30 ¼"
Collection of MBNA America

41. *We're On Our Way,* 1944
Illustration for Brown and Bigelow calendar, 1944.
Oil on canvas, 44" x 34"
Cawley Family Collection

42. *Soldiers of the Soil,* 1942
Illustration for Brown and Bigelow calendar, 1943.
Oil on canvas, 46" x 35"
Courtesy of the Bank One Art Collection, Bequest of Carolyn Wyeth

43. *The Home Coming—composition drawing,* 1944
Charcoal on paper, 50 ⅛" x 38 ³⁄₁₆"
Collection of the Brandywine River Museum, Bequest of Carolyn Wyeth

44. *Our Emblem,* c. 1944
Illustration for Brown and Bigelow calendar, 1944.
Oil on Renaissance Panel, 30" x 22 ⅝"
© Courtesy Brigham Young University Museum of Art. All rights reserved.

James Wyeth

Opposite Essay by David Michaelis
Russians Off the Coast of Maine, 1988
Mixed Media, 29 ½" x 39"
Private Collection

45. *Draft Age,* 1965
Oil on canvas, 36" x 30"
Collection of the Brandywine River Museum, Museum purchase

46. *Portrait of Thomas Jefferson,* 1975
Reproduced for "The Man From Monticello." *Time* magazine, July 4, 1976.
Watercolor and drybrush on paper, 14 ½" x 12 ½"
Private Collection

47. *Jefferson,* 1975
Mixed media on board, 13 ¹³⁄₁₆" x 10 ¹⁵⁄₁₆"
Collection of Mrs. Jane Wyeth

48. *Dome Room,* 1995
Oil on panel, 36" x 30"
The Warner Collection of Gulf States Paper Corporation, Tuscaloosa, AL

49. *Portrait of Jean Kennedy Smith,* 1972
Oil on canvas, 22" x 19"
Private Collection

50. *Senator Robert F. Kennedy Reading,* 1966
Pencil on paper
Collection of the artist

51. *Senator Robert F. Kennedy and Senator Edward M. Kennedy,* c. 1966
Pencil on paper, 10 ½" x 13 ½"
Collection of the artist

52. *Studies of Senator Robert F. Kennedy,* 1966
Pencil on paper, 11" x 14"
Collection of the artist

53. *Senator Edward M. Kennedy—study,* c. 1966
Pencil on paper, 14″ x 11″
Collection of the artist

54. *Portrait of JFK—study with four images,* 1966
Pencil on paper, 13½″ x 10½″
Collection of the artist

55. *John F. Kennedy,* 1966
Pencil on paper, 15″ x 26½″
Collection of the artist

56. *Portrait of President John F. Kennedy—*
oil study, 1967
Oil on canvas, 14″ x 18″
Collection of the artist

57. *Portrait of President John F. Kennedy,* 1967
Oil on canvas, 16″ x 29″
Collection of the artist

58. *Detail—Portrait of President John F. Kennedy,*
1967

59. *Jimmy Carter,* 1976
Reproduced for "Man-of-the-Year" cover.
Time magazine, January 3, 1977.
Watercolor on paper, 14″ x 11″
National Portrait Gallery, Smithsonian
Institution, Gift of *Time* magazine

60. *Jimmy Carter,* 1976
Pencil on paper, 8″ x 11″
Collection of Frank E. Fowler

61. *Support,* late 1960s
Commissioned for *Eyewitness to Space*
by NASA and The National Gallery of Art
to Record America's Space Program,
New York: Harry N. Abrams, Inc., 1963–1970.
Watercolor on paper, 21″ x 24″
Collection of the National Air and Space
Museum, Smithsonian Institution,
Washington, D.C.

62. *C-97 Landing in Vietnam,* c. 1969
Watercolor on paper, 38½″ x 19¼″
Collection of the Delaware Air National Guard

63. Detail—*T-Minus 3 Hours 30 Minutes and*
Counting, late 1960s
Commissioned for *Eyewitness to Space*
by NASA and The National Gallery of Art
to Record America's Space Program,
New York: Harry N. Abrams, Inc., 1963–1970.
Watercolor on paper, 24″ x 31″
Collection of the National Air and Space
Museum, Smithsonian Institution,
Washington, D.C.

64. *Gemini Launch Pad,* late 1960s
Commissioned for *Eyewitness to Space*
by NASA and The National Gallery of Art
to Record America's Space Program,
New York: Harry N. Abrams, Inc., 1963-1970.
Watercolor on paper, 27″ x 34″
Collection of the National Air and Space
Museum, Smithsonian Institution,
Washington, D.C.

65. *Wide Load,* late 1960s
Commissioned for *Eyewitness to Space*
by NASA and The National Gallery of Art
to Record America's Space Program,
New York: Harry N. Abrams, Inc., 1963–1970.
Watercolor on paper, 27″ x 34″
Collection of the National Air and Space
Museum, Smithsonian Institution,
Washington, D.C.

66. *Adam and Eve and the C-97,* c. 1969
Oil on parachute nylon, 10′ x 30′ 9″
Collection of the Delaware Air National Guard

67. *Ehrlichman pleading before jury, policeman*
guarding court room 6, 1974
Commissioned for "American Character:
Trial and Triumph." *Harper's* magazine,
October 1974.
Pencil on paper, 11″ x 14″
Collection of the artist

68. *John Ehrlichman underneath flag,* 1974
Commissioned for "American Character:
Trial and Triumph." *Harper's* magazine,
October 1974.
Pencil on paper, 14″ x 11″
Collection of the artist

69. *"St. Clair questioning Ehrlichman,"* 1974
Commissioned for "American Character:
Trial and Triumph." *Harper's* magazine,
October 1974.
Pencil on paper, 11″ x 14″
Collection of the artist

70. *John Ehrlichman wearing headphones,* 1974
Commissioned for "American Character:
Trial and Triumph." *Harper's* magazine,
October 1974.
Pencil on paper, 11″ x 14″
Collection of the artist

71. *"Ehrlichman starts to break down and turns*
away from jury," 1974
Commissioned for "American Character:
Trial and Triumph.' *Harper's* magazine,
October 1974.
Pencil on paper, 14″ x 11″
Collection of the artist

72. *"H. R. H. watching videotape of himself giving*
his Ervin committee testimony," 1974
Commissioned for "American Character:
Trial and Triumph." *Harper's* magazine,
October 1974.
Pencil on paper, 11″ x 14″
Collection of the artist

73. *"Mr. Ben-Veniste going after C. Colson,"* 1974
Commissioned for "American Character:
Trial and Triumph." *Harper's* magazine,
October 1974.
Pencil on paper, 11″ x 12″
Collection of the artist

74. "E. Howard Hunt," 1974

Commissioned for "American Character: Trial and Triumph." *Harper's* magazine, October 1974.

Pencil on paper, 11″ x 14″

Collection of the artist

75. "As Ehrlichman sat down at the defense table, Liddy leapt to his feet and saluted him," 1974

Commissioned for "American Character: Trial and Triumph." *Harper's* magazine, October 1974.

Pencil on paper, 11″ x 14″

Collection of the artist

76. "C. Colson listening to taped conversations of he and Nixon, and then <u>again</u> testifying that he didn't recall it," 1974

Commissioned for "American Character: Trial and Triumph." *Harper's* magazine, October 1974.

Pencil on paper, 14″ x 11″

Collection of the artist

77. "Haldeman conferring with his attorney Wilson," 1974

Commissioned for "American Character: Trial and Triumph." *Harper's* magazine, October 1974.

Pencil on paper, 11″ x 14″

Collection of the artist

78. "Mr. Wilson again interrupts Mr. Neal's cross of H. R. H.," 1974

Commissioned for "American Character: Trial and Triumph." *Harper's* magazine, October 1974.

Pencil on paper, 11″ x 14″

Collection of the artist

79. "Special Prosecutor Neal tries to impeach Ehrlichman's prior testimony," 1974

Commissioned for "American Character: Trial and Triumph." *Harper's* magazine, October 1974.

Pencil on paper, 11″ x 14″

Collection of the artist

80. "Judge Sirica," 1974

Commissioned for "American Character: Trial and Triumph." *Harper's* magazine, October 1974.

Pencil on paper, 11″ x 14″

Collection of the artist

81. "Special prosecutor Neal giving his final summation to the jury," 1974

Commissioned for "American Character: Trial and Triumph." *Harper's* magazine, October 1974.

Pencil on paper, 9″ x 12″

Collection of the artist

82. "Sirica—Wilson—St. Clair," 1974

Commissioned for "American Character: Trial and Triumph." *Harper's* magazine, October 1974.

Pencil on paper, 11″ x 14″

Collection of the artist

83. *Albert Jenner, minority council, and Roger Mudd, of CBS-TV*, 1974

Commissioned for "American Character: Trial and Triumph." *Harper's* magazine, October 1974.

Pencil on paper, 11″ x 14″

Collection of the artist

84. "Jenner," 1974

Commissioned for "American Character: Trial and Triumph." *Harper's* magazine, October 1974.

Pencil on paper, 11″ x 14″

Collection of the artist

85. *Mr. Rodino, Chairman*, 1974

Commissioned for "American Character: Trial and Triumph." *Harper's* magazine, October 1974.

Pencil on paper, 11″ x 14″

Collection of the artist

86. *Mr. Peter Rodino*, 1974

Commissioned for "American Character: Trial and Triumph." *Harper's* magazine, October 1974.

Pencil on paper, 11″ x 14″

Collection of the artist

87. *Mr. Sandman*, 1974

Commissioned for "American Character: Trial and Triumph." *Harper's* magazine, October 1974.

Pencil on paper, 11″ x 14″

Collection of the artist

88. *Mr. Froehlich*, 1974

Commissioned for "American Character: Trial and Triumph." *Harper's* magazine, October 1974.

Pencil on paper, 11″ x 14″

Collection of the artist

89. *Mr. Caldwell Butler, Mr. Charles Wiggins*, 1974

Commissioned for "American Character: Trial and Triumph." *Harper's* magazine, October 1974.

Pencil on paper, 11″ x 14″

Collection of the artist

90. *Mr. Cohen*, 1974

Commissioned for "American Character: Trial and Triumph." *Harper's* magazine, October 1974.

Pencil on paper, 11″ x 14″

Collection of the artist

91. "Mr. Lott," 1974

Commissioned for "American Character: Trial and Triumph." *Harper's* magazine, October 1974.

Pencil on paper, 11″ x 14″

Collection of the artist

92. *Rev. Drinan,* 1974

 Commissioned for "American Character: Trial and Triumph." *Harper's* magazine, October 1974.

 Pencil on paper, 11″ x 14″

 Collection of the artist

93. *"U. S. Supreme Court House—early morning— T.V. lights producing an eerie glow,"* 1974

 Commissioned for "American Character: Trial and Triumph." *Harper's* magazine, October 1974.

 Pencil on paper, 11″ x 14″

 Collection of the artist

94. *"The Press,"* 1974

 Commissioned for "American Character: Trial and Triumph." *Harper's* magazine, October 1974.

 Pencil on paper, 9″ x 12″

 Collection of the artist

95. *"Press room after verdict,"* 1974

 Commissioned for "American Character: Trial and Triumph." *Harper's* magazine, October 1974.

 Pencil on paper, 11″ x 14″

 Collection of the artist

96. *"Fred Graham, CBS, timing his report for telecast,"* 1974

 Commissioned for "American Character: Trial and Triumph." *Harper's* magazine, October 1974.

 Pencil on paper, 9″ x 12″

 Collection of the artist

97. *"CBS artist has court bailiff pose for portrait,"* 1974

 Commissioned for "American Character: Trial and Triumph." *Harper's* magazine, October 1974.

 Pencil on paper, 11″ x 14″

 Collection of the artist

98. *Christmas Eve at the White House,* 1981

 Reproduced for presidential Christmas card. Hallmark Cards, 1981.

 Oil on canvas, 11″ x 12″

 Collection of the artist

99. *Study for Christmas Eve at the White House,* 1981

 Mixed media, 9½″ x 11¼″

 Collection of Mrs. Louis Cabot

100. *Vice President's House,* 1996

 Reproduced for vice presidential Christmas card, 1998.

 Oil on canvas, 24″ x 36″

 Private Collection

101. *Christmas Morning at the White House,* 1984

 Reproduced for presidential Christmas card. Hallmark Cards, 1984.

 Mixed media, 12″ x 9″

 Collection of the artist

102. *Sesquicentennial,* 1989

 Mixed media, 22⅜″ x 30″

 Collection of Mr. Daniel K. Thorne

103. *Islanders,* 1990

 Oil on panel, 30″ x 40″

 Private Collection

Notes

[1] Betsy James Wyeth, ed. *The Wyeths by N. C. Wyeth: The Intimate Correspondence of N. C. Wyeth 1901–1945,* Boston: Gambit, 1971, p. 47.

[2] Ibid., p. 573.

[3] Ibid., p. 553.

[4] Ibid., p. 843.

[5] Joseph Roddy, "Another Wyeth: The Portrait Artist Is a Young Man." *Look,* April 2, 1968, p. 58.

[6] Jerilyn Hughes, "What Kind of Rebel Is He?" *Pace,* December 1967, p. 37.

[7] Hugh Sidey, "Those Evergreen Echoes," *Time* magazine, December 28, 1981.

Acknowledgments

This exhibition and catalog are testaments to the collaborative efforts of many wonderful people and corporations that are supportive of the work of the Wyeths. The first to be mentioned is MBNA America, corporate sponsor for the show and lender of several works in the exhibition. The generosity and support of MBNA for the Farnsworth Art Museum in general, and for this exhibition specifically, have been boundless and much appreciated. We also thank the people of MBNA, most notably Sandra Johnson, Lisa McMonigle, and Trish Kerr, for lending their considerable talents and efforts to the design of the catalog and other printed material. Thanks also go to Robert Lescher, literary agent for the Wyeth family, Janet Bush, Executive Editor at Bulfinch Press/Little, Brown, and her colleagues Helen Watt and Melissa Langen, for believing in the project enough to work with extremely tight deadlines and still turn out a wonderful book.

Christine Podmaniczky, associate curator of the N. C. Wyeth collection at the Brandywine River Museum, has been extremely generous in sharing her time and knowledge of N. C. Wyeth's war work, for which we are indebted to her. Dr. Joyce Hill Stoner, professor at the University of Delaware and paintings conservator, treated several of the paintings in the exhibition, enabling them to look their best. We are grateful for her talent and her sage advice on many different aspects of the show. Special thanks go to Catherine Stevens and Jennifer Mies in Senator Stevens's office for their assistance in negotiating the labyrinthine Washington channels, and to Mabel Cabot, whose initial enthusiasm and experienced advice spearheaded the project.

Of course our sincerest gratitude is extended to the lenders to the exhibition, and those who agreed to have their works represented in the catalog, the list of whom could fill another book. We would also like to thank those individuals who have assisted the exhibition in a variety of capacities with their experience and kindness, including Tom Brokaw, Hugh Sidey, David Michaelis, James Dean, William McSweeny, Colonel Dave Jacobs, Captain Timothy Hoyle, Erin O'Connor, Kathleen Lund, Steve Morrison, Judi Knickle, Mary Beth Dolan, Mary Blair, and Elizabeth Williamson.

Many thanks have to go to Chris Crosman, Director, Victoria Woodhull, Associate Director, and the staff here at the Farnsworth Art Museum for their cheerful teamwork in preparing for this show; Edith Murphy, Registrar, Angela Waldron, Assistant Registrar, Jason Rogenes, Preparator, Keith Gleason, Director of Marketing and Development, Katie Heckel, Director of Retail Services, and especially my tireless assistant, Sarah A. Wilbur, Assistant Wyeth Center Curator.

This exhibition would never have come to fruition without the support of Jamie and Phyllis Wyeth, who took a small seed of an idea and encouraged it to grow. Working with them is always an honor and a privilege.

Lauren Raye Smith
Wyeth Center Curator
Farnsworth Art Museum